Sixty Tips for Creative iPhone Photography

D1025924

Martina Holmberg (www.martinaholmberg.com)

Translation: Johan Steensland
Editor: Jocelyn Howell
Copyeditor: Aimee Baldridge
Layout and Type: Tobias Hagberg
Cover Design: Anna Diechtierow
Printer: Tallinna Raamatutrükikoda OÜ
Printed in Estonia

ISBN 978-1-937538-12-5

Rocky Nook Inc.
802 East Cota St., 3rd Floor
Santa Barbara, CA 93103

www.rockynook.com

Library of Congress Cataloging-in-Publication Data
Holmberg, Martina.
[Bättre bilder, iPhone. English]
Sixty tips for creative iPhone photography / by Martina Holmberg. -- 1st ed.
 p. cm.
ISBN 978-1-937538-12-5 (softcover : alk. paper)
1. iPhone (Smartphone) 2. Photography, Artistic. 3. Photography--Digital techniques. I. Title.
TR263.I64H65 2012
770--dc23
 2012013793

Distributed by O'Reilly Media
1005 Gravenstein Highway North
Sebastopol, CA 95472

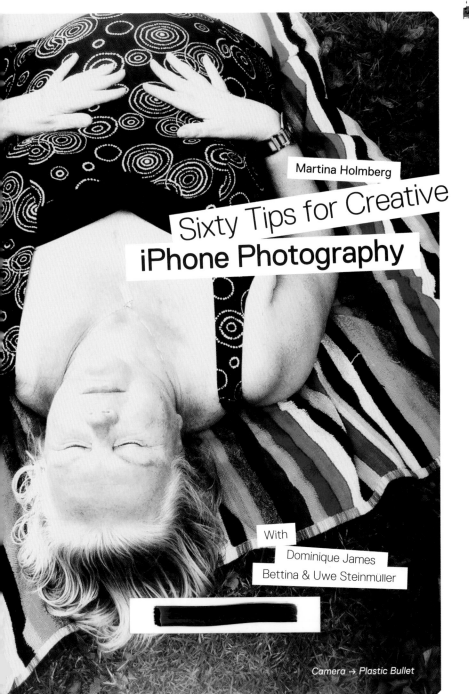

Martina Holmberg

Sixty Tips for Creative
iPhone Photography

With
Dominique James
Bettina & Uwe Steinmüller

Camera → Plastic Bullet

Contents

Publisher's Foreword

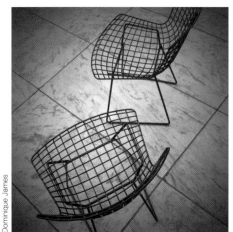

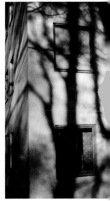

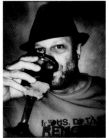

Dominique James

Bettina & Uwe Steinmüller

Two years ago, I met Swedish publisher Tobias Hagberg in Stockholm. His "Bättre Bilder" series of inspiring and lovingly written pocket books covers many aspects of modern photography, and we have already published a number of them in English at Rocky Nook and in German at dpunkt as part of our "edition espresso" series.

Tobias was excited by the idea of dedicating a whole book to the subject of iPhone photography and showed me some photos taken by Martina Holmberg, a young artist who was recently nominated for the Scanpix Grand Photography Prize. The problem was that Martina is an established photographer, and had no spare time and little interest in playing with the iPhone's camera, let alone using such a "toy" as a creative photographic tool.

But Tobias was persistent and, having had an iPhone more or less forced on her, it was only a matter of weeks before Martina was captivated by this fantastic little box of tricks—just like you, me, and millions of other iPhone users. iPhone photography means shooting unfettered, without worrying about apertures, ISO, or shutter speeds. Sprinkled with the device's own special brand of quirks and bugs is an ever-increasing range of wonderful apps that transform photography into a new kind of creative game.

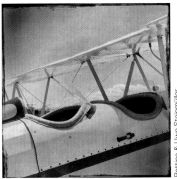

Bettina & Uwe Steinmüller

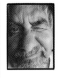

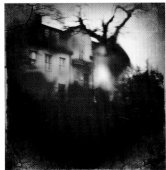

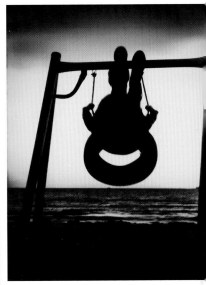

But it's not just about fun—the iPhone also sparks a creative potential unknown in the world of traditional photography. In short, the project gave Martina a boost, and the result is this book of 59 creative and technical tips and tricks.

We ended up with 59 tips and an unwieldy book title that spurred us on to search for the all-important 60th pointer. And here it is: Have you ever noticed that the iPhone's shutter releases when you take your finger off the shutter-release button, not when you tap it? This makes releasing the shutter a gentler process and helps prevent unwanted camera shake. You can hold your finger on the button as you steady the camera, then remove it when you're ready to take a picture.

Together with the author, we also decided to include two Guest Galleries in the book to provide you with extra inspiration for your own iPhone photo exploits. Two photographers, Dominique James and Uwe Steinmüller, lent us six images each from their iPhone portfolios to get your juices flowing.

By the way, some of the technical tips apply exclusively to the newer iPhone 4 and 4s models, but most of our ideas apply to earlier models, too.

Have fun with this book and your iPhone!

Gerhard Rossbach
dpunkt.verlag
Rocky Nook, Inc.

Photos on this spread by Martina Holmberg, except where otherwise noted

Camera → Plastic Bullet

Preface

When I was approached about writing this book, I didn't even own an iPhone. An iPhone was merely another toy for the techno geeks. It offered nothing to us photographers. The camera in the iPhone has relatively low resolution, and you can't change its lens. So how are you supposed to take good pictures?

Sure, I thought the assignment sounded exciting. Writing a book would be a welcome interruption to the humdrum of my work as a press and feature photographer. So I said yes. But it was with mixed emotions that I headed out for my first shots with a toy I had already dismissed.

Six hundred pictures and a few days later things had changed. I was sold. The simplicity of the built-in camera brought back that special happiness that once upon a time made me get into photography. I rediscovered the joy of watching the banalities and passing moments of everyday life. It's the camera's limitations that make me focus fully on my subject. My mind opens and the child inside me awakens.

As you begin to focus on your environment more carefully, you rediscover your surroundings and you suddenly see subjects you missed before. You focus on the picture's expression and content. And even though the camera has lower resolution than a DSLR and is of lower technical quality, you'll be surprised to see what you can do with the images.

Shoot from the hip or shoot in spaces too narrow for a larger camera. Get inspired by the results from easily installed apps that can bring out the mood in a picture. Perhaps you've already discovered the popular *Hipstamatic* app that gives you the feeling of shooting with an old analog camera. The images it creates gain an aura of nostalgia and can turn into fantastic pieces of art.

Explore the enormous assortment of apps on the market and all their exciting effects. But remember, you're the one taking the pictures; it's not the camera or the apps. It's easy to get carried away by the opportunities of new technology. Sure, it can be rewarding to experiment with effects. But if you want to get the most out of your iPhone, it's a good idea to figure out which of the apps are best at bringing out a certain mood or expression.

It's my hope that this book will inspire you to rediscover your surroundings, to get your creativity flowing, and to have serious fun with your iPhone. After my own journey from a skeptic to a fan, I am certain that the seeing, the creativity, and the joy will help you develop as a photographer.

Martina Holmberg

Camera → Plastic Bullet

Chapter 1
Get Started

1 What's an *app*?

An *app* (short for "application") is a smallish program for the iPhone and other smartphones. From Apple's *App Store* you can download apps for work, music, health, and—of course—video and photography. To view all of the photography apps in the *App Store*, you just select the category *Photo & Video*.

In this book you'll learn about lots of useful, fun, and helpful apps. Many apps are free, or almost free. Rarely do they cost more than a few dollars. The iPhone comes equipped with the *Camera* app, which allows you to shoot photos and videos, and the *Photos* app, which stores your images and videos and allows you to perform some editing tasks. It really doesn't matter exactly which apps you fancy. The important thing is that you have fun, and that you find apps that help you express yourself with your images. Read more in tip 17.

Camera → *Lo-Mob* → *SwankoLab*

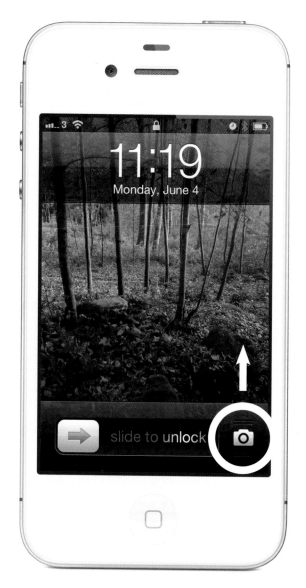

2 Say "Say cheese!" fast

Speed and simplicity are two major advantages of taking pictures with an iPhone. You can start shooting right away, even without unlocking the display. Even when your iPhone is locked, you can start shooting right away. Just touch the camera icon next to the unlock slider and swipe it upward to reveal the *Camera* app. Another way to shoot is by using the volume button. When you're using the *Camera* app, just press the *plus* volume button to take a picture. It's that simple.

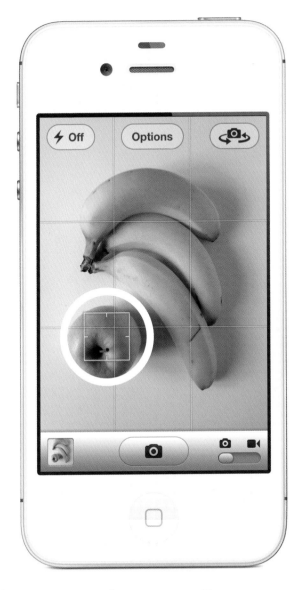

3 Focus with your finger

The camera in your iPhone will automatically focus on your subject. But as with any camera, you and the automatic focus may disagree on what your subject is. Fortunately, that's easily fixed. Before taking the picture, locate your subject on the display and touch it with your finger. Your iPhone will then adjust both focus and exposure. If you touch and hold, your iPhone will lock exposure and focus. Then you can recompose the shot before taking the picture if you want to.

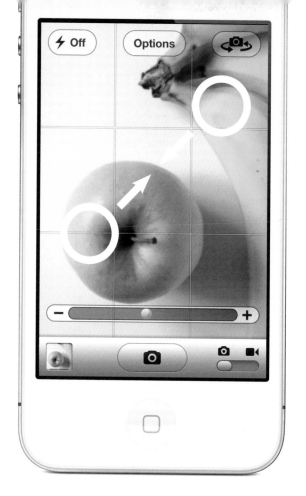

4 Pinch to zoom

Do you want a zoom lens? On your iPhone you zoom by pinching and "un-pinching" with two fingers on the display. You can also use the plus and minus symbols at the bottom of the display. Just keep in mind that your iPhone lacks a real zoom lens. That means zooming in is done digitally, which is the same thing as cropping your image (see tip 6). A cropped picture will always be of lower quality if you try to display or print it at the same size as the original, uncropped picture. Since you'll get the same result by cropping your image later on, you might choose to do that instead of zooming—and save the job for a rainy day.

If zooming while shooting is your thing, you may want to try the grid overlay. The grid is superimposed on your display and makes it easy to compose your image according to the rule of thirds. It may also help you in other situations, such as when you photograph a building and want it to appear as straight as possible. You access the grid by touching *Options*, followed by *Grid*.

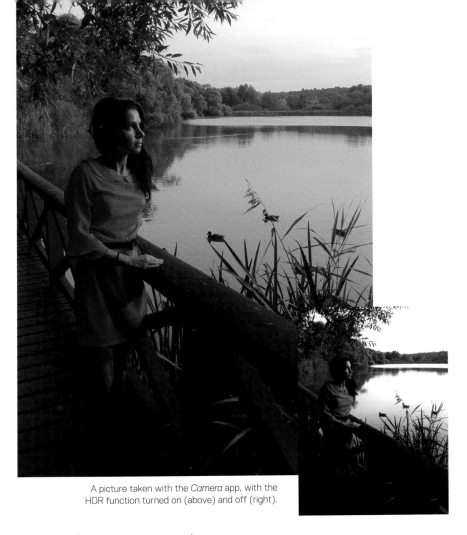

A picture taken with the *Camera* app, with the HDR function turned on (above) and off (right).

5 Capture the entire dynamic range

Despite modern technology, the digital camera still has a long way to go before it can compete with the human eye. The range of light intensities in a scene, from dark shadows to bright sunlight, is often so great that the camera's sensor can register only a part of it. But your iPhone comes equipped with a popular function called "HDR" (high dynamic range). By using it, you can capture a broader range of light intensities. Your iPhone achieves this by rapidly taking two shots and then automatically blending them into a final image that holds detail in both shadows and highlights. You turn HDR on by touching *Options*, followed by *HDR*.

6 Improve your image

The *Photos* app is capable of more than just displaying your pictures. By tapping the icons at the bottom of the display, you can adjust your picture with the four basic functions: Rotate, Crop, Auto-Enhance, and Remove Red-Eye. Auto-Enhance is perhaps the most useful of the functions. In one go, it adjusts white balance, color saturation, and contrast. Go ahead and try it! Tap *Edit* at top right; then tap the magic wand. Happy with what you see? Tap *Save*.

7 Crop to perfection

A careful framing of the subject is an essential part of photo composition. Do you have a picture that might benefit from a little cropping? With your iPhone you crop images right in the *Photos* app. Tap *Edit* at the top-right corner of your display, and then tap the crop symbol that appears at the bottom-right corner. This will give you a frame around your image. You adjust your framing by simply touching and dragging the four corners. Should you want your image to have a particular aspect ratio, like 3:2 or 4:3, use the Constrain function. Tap *Crop* when you're done. And don't forget to save.

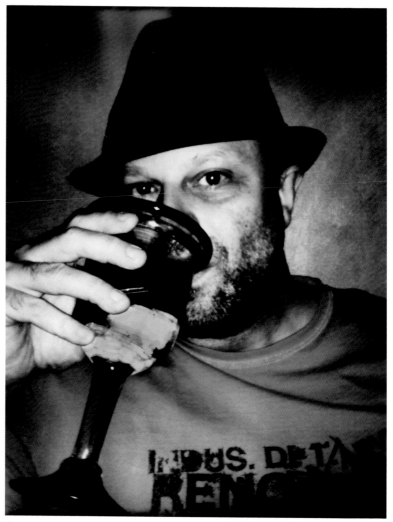

Camera with LED flash → *Plastic Bullet*

8 A small extra glimpse of light

Sometimes there just isn't enough light to take a picture. For those situations, your iPhone sports a built-in flash. Even though the small LED is no bolt of lightning, it gets the job done for dark subjects within close range. You activate the flash in the *Camera* app by tapping the flash symbol, followed by *Auto* or *On*. If you photograph people, they will probably have red eyes in pictures taken with the flash. You can remove red-eye later in the *Photos* app (see tip 6).

9 Use the cloud to copy images to your iPad or desktop

With the Photostream function in Apple's iCloud service, you can automatically transfer your new photos from your iPhone to an iPad or a personal computer. This service is free as long as you use less than 5 GB of storage. Because Photostream doesn't work with a mobile 3G connection, you'll need a wireless network to use it. And you have to configure each of your devices to use iCloud.

You should be aware that this function is unsuitable for automatic backup of your photos. Old photos in Photostream will be removed when new ones appear on your devices. Do you want to know more? Read the instructions at http://www.apple.com/icloud/setup.

Photo Stream automatically transfers pictures to your computer or iPad via Apple's servers.

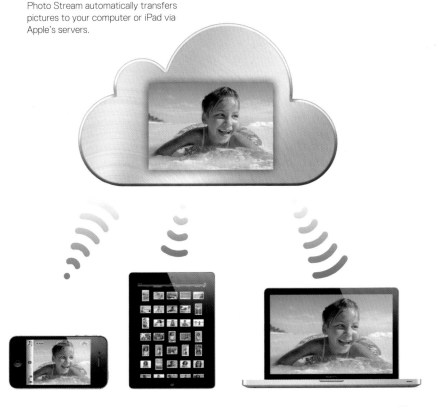

10 The other way around: Transfer images from your desktop to your iPhone

Here's an unusual way of using your iPhone: Instead of taking pictures with it and transferring them to your computer, do it the other way around. Use iTunes on your computer to transfer your ordinary digital images to your iPhone. Then you'll be able to apply all of your wonderful apps to your images, instead of editing them as usual in Photoshop on your computer.

Start by connecting your iPhone to your computer with the USB cable. Open iTunes manually if it doesn't open automatically. Select your iPhone's name below the menu item *Devices* in the left panel, and select the *Photos* tab on the right. Select the folder containing the images you want to transfer with the *Sync Photos from* drop-down menu. Last, click *Apply* at the bottom of the iTunes window and your photos will be copied to your iPhone. Keep in mind that iTunes may have to adjust your images a bit to make them work on your iPhone. This may take a while if you're transferring many photos.

Are you curious about the results? Examples of images edited with apps can be found in tip 27.

This picture was taken with the regular *Camera* app. Then the *Lo-Mob* app was used to give it a dirty, ruined look, and the *SwankoLab* app was used to create the warm color tone.

Camera → *Lo-Mob* → *SwankoLab*

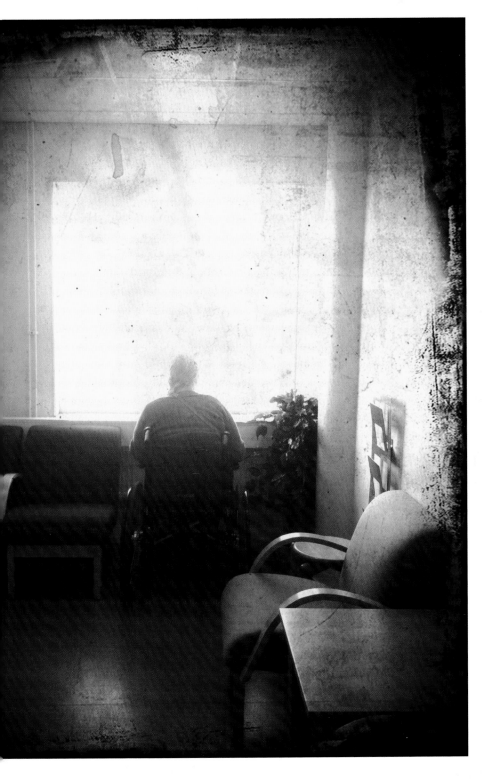

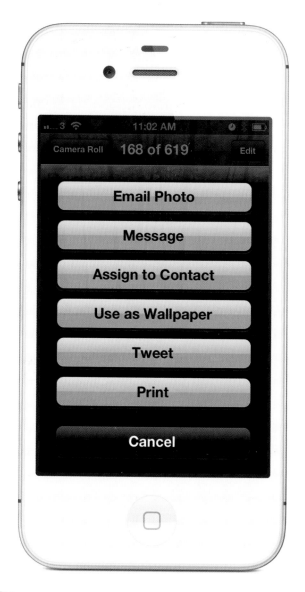

11 Share your images

If there's an image in your collection that you're especially happy about, you might want to share it with friends and family. Well, that's easy. Select the image in the *Photos* app and tap the share symbol (a small frame with an arrow) at the bottom of the display. A menu appears with items such as *Email Photo*, *Message*, and *Tweet*. Make a selection and type your message—spread the joy. This also works with the video clips you've shot with your iPhone (see chapter 7).

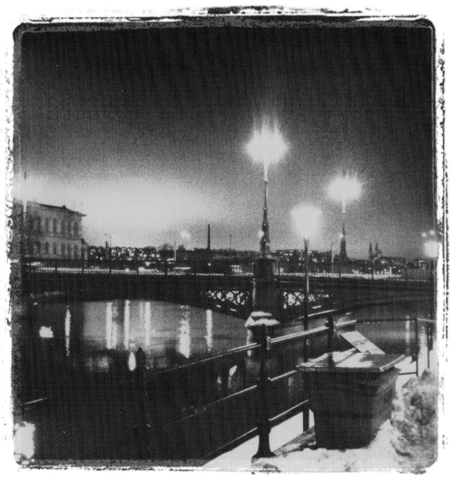

Camera → Instagram

12 Size matters

You should probably know that image file size and resolution might differ between the different apps. Some apps let you choose the size of the images they save. In those apps, you select the size you prefer in the app's settings. The lowest resolution (smallest image file size) is a good choice when you want to publish your image on the web or need the app to operate as fast as possible. But if you'd like to print your image, you'll want to choose the highest possible resolution.

 When you take pictures with your iPhone, it's a good idea to do it from within the *Camera* app. That way you can be certain that you have the best possible original image to work with in your apps. And you'll always have your original file untouched, should you later want to create another version of it.

13 Avoid sore iPhone fingers

Taking pictures with an iPhone is so fun that it's borderline addictive. If you shoot and experiment often, you'll tap that little display a lot. As with all repetitive tasks, there's a risk of sustaining problems with muscles and joints. Be alert to any kind of soreness or ache in your fingers. Take breaks! This is an important and sincere warning because the kinds of problems you might develop can be hard to recover from. An iPhone sure is fun, but not enough fun to risk your health for.

Hipstamatic with the "Dreampop" effect

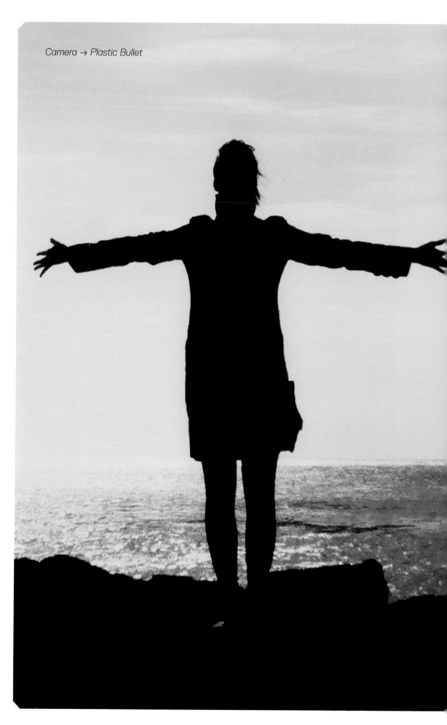

Camera → Plastic Bullet

Chapter 2
Opportunities in Limitations

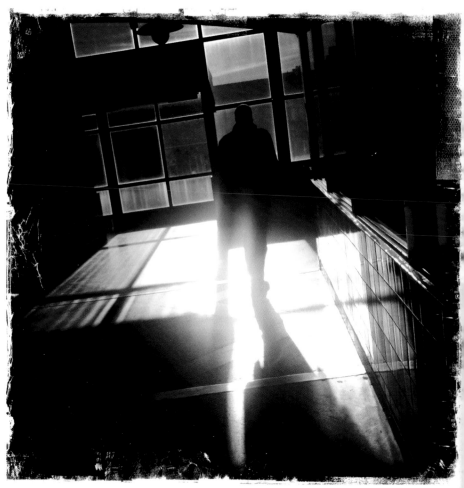

Hipstamatic

14 Concentrate on your subject

Your iPhone camera is relatively limited. At first you might see the limitations as something negative, but the fact is that they're one of the best things about the camera. Because you can't change lenses, you have to compose your image with the built-in wide-angle lens. That will force you to move around more and try out new and exciting perspectives and compositions. You don't have to worry about choosing the most suitable lens, so you can concentrate on your subject.

15 See the light

On your iPhone, you can't set the camera's ISO, f-stop, or shutter speed. But because you rely on the automatic settings, you'll become more aware of how different lighting conditions affect your images. You'll probably start paying more attention to the light and how it changes with the season, weather, and time of day. The wall of a building can be empty and boring. But in a dramatic light that creates exciting shadows, that same wall can turn into an interesting subject. Photography is often about seeing opportunities to take exciting pictures in the conditions you find yourself in. You just have to adjust your shooting to each situation in the best way possible.

Camera → Plastic Bullet

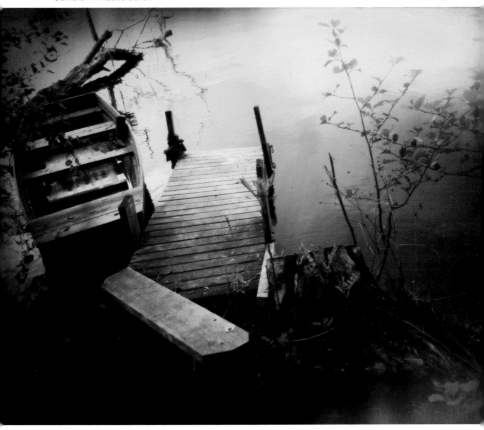

16 Photography is supposed to be fun

Because an iPhone is so easy to carry and use, it's only natural to take it out and start shooting whenever you feel like it. This encourages you to have a joyful and unforced attitude toward taking pictures. Any traces of performance anxiety disappear. Instead, you can be playful and dare to experiment. With an iPhone, all rules vanish. The only thing that's important is that you photograph for yourself and no one else.

The more you photograph, the more you'll learn to see. Ordinary subjects will suddenly become interesting. You'll probably find subjects in places you previously just passed by without seeing anything interesting. And once you turn that photographic eye on, it's hard to turn it off. Do you want to take a picture? Then take a picture.

In chapter 3 you'll find lots of tips about how to develop your photographic eye with your iPhone.

Camera → Plastic Bullet

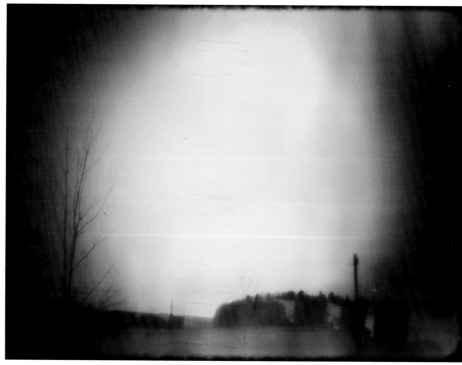

17 Set the mood with photo apps

An ordinary camera doesn't have any apps. But your iPhone can have any number of them—or as many as you install. By trying different photo apps, you get a sense of how light and color affect your subjects. The expression in your images will change right before your eyes on the display. And when you start using your apps more purposefully to bring out a certain mood in a picture, you'll enjoy the creative process even more.

Are you disappointed with the effects of an app? Just hit undo and try other effects. Or why don't you add yet another effect or two? You don't need a computer with an image editor. With your apps you'll create pictures that are both personal and full of feeling—right on your iPhone.

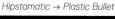

Hipstamatic → Plastic Bullet

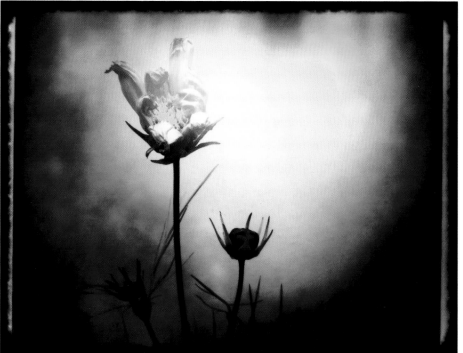

18 Never mind the histogram

An ordinary digital camera can produce what is called a "histogram" of an image. A histogram is a graphic representation of the brightness values in the image, from dark to light. You can use it to assess whether your exposure is correct. Your iPhone doesn't generate histograms. And that's just as well. Compared to an ordinary digital camera, the iPhone produces images of relatively low technical quality. The images are a bit harsh and strong in contrast. So forget about the histogram and don't worry about technical perfection. Instead, try to see the advantages of the imperfection of your images. This will teach you to see beyond technical shortcomings. As a result, you'll focus more intently on your shooting.

Compared to a retouched, refined, and optimized image taken with an expensive camera, an image taken with an iPhone often feels more spontaneous and genuine. An iPhone is the perfect tool for capturing the realism in the mundane and the unromantic. Reality is seldom strikingly beautiful or picture perfect. It contains light and darkness, beauty and ugliness. And that's perhaps the way it's supposed to be.

Hipstamatic

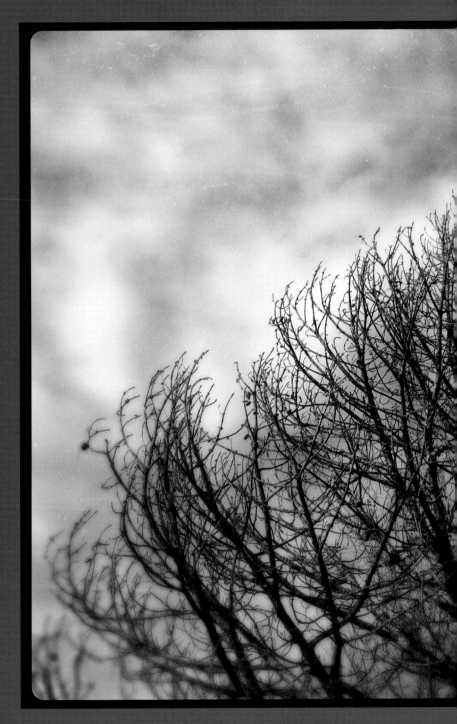

Guest Gallery
Dominique James

Crowning Glory The beauty of a tree is there for everyone to see when it shamelessly sheds its leaves and unabashedly reveals itself in winter. As they say, you only get to know one's character once things are seen from inside. (Vidalia, GA)

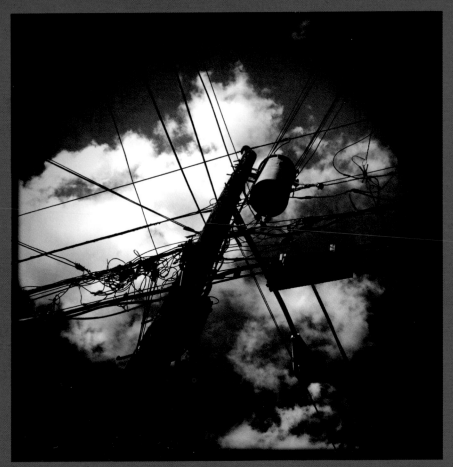

Electrical Pole We will probably never know just how many poles there are in the United States and in the wide, wide world. While they tend to mar the urban landscape, they are so ubiquitous that we somehow don't really see them. Only the linemen pay close attention to them. I can only surmise that every line supported by this pole represents a connection of infinite possibilities. (Jersey City, NJ)

Dominique James has been a commercial and fine art photographer for nearly 30 years. He is currently based in New York City and Atlanta, Georgia. James began his career in Asia, where he photographed countless famous individuals, including celebrated entertainers and top fashion models, as well as high-ranking politicians and prominent socialites.

To date, James has shown his work in more than 50 solo and group photography exhibits. They include "We Are All Photographers Now!," held in New York in 2009; "Famous," at the University of the Philippines Diliman, Quezon City, in 2007; and "Avon, Kiss Cancer Goodbye," at the Shangri-La EDSA Plaza in Mandaluyong, Philippines.

James also regularly conducts popular workshops for models and photographers. He frequently

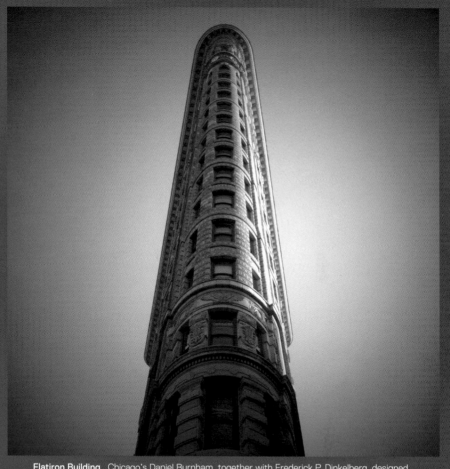

Flatiron Building Chicago's Daniel Burnham, together with Frederick P. Dinkelberg, designed this groundbreaking skyscraper as a vertical Renaissance palazzo in the Beaux-Arts style. It was originally named the "Fuller Building," but because its curious triangular shape evokes a cast-iron clothes iron, it quickly earned the moniker "flatiron." In 1966, it was designated a New York City landmark. In 1979, it was entered into the National Register of Historic Places. And in 1989, it was recognized as a National Historic Landmark. (New York, NY)

serves as a judge and a consultant to photography contests, model searches, beauty pageants, and talent competitions.

While James is best known for his celebrity portraits, the scope of his work includes fashion, portrait, product, still life, commercial, advertising, corporate, food, and landscape photography. He is also an expert in visual concept creation, design, and digital imaging post-production. His international clients include Avon, Apple, AIG, Epson, Fuji, and Nikon.

Worldwide, Dominique James is an Apple Certified Pro and Apple Certified Trainer for Aperture 1, 2, and 3. In Asia, he is an Epson Stylus Pro Photographer and a Nikon Pro Photographer.

More from Dominique James
dominiquejames.wordpress.com
dominiquejames@mac.com

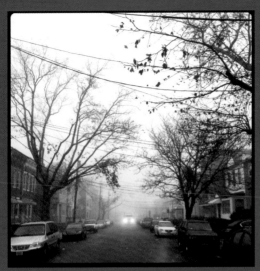

A Foggy Day in Jersey Town While most people choose
to stay safely indoors during inclement weather, photo-
graphers elect to brave nature. A frigid and foggy, wet
and wintry morning can transform an ordinary neighbor-
hood into a mystical, magical landscape that you'd hardly
recognize if it were your own street. (Jersey City, NJ)

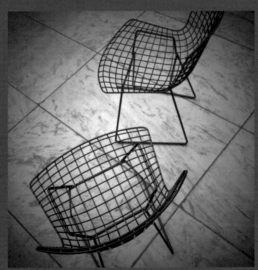

Two Empty Chairs A pair of famous Bertoia-designed
chairs decorates rectangular slabs of the Georgia Marble
Company's Pearl Grey stone at the Museum of Modern
Art's open-air Abby Aldrich Rockefeller Sculpture Garden.
The garden is flanked by the glass-encased museum that
architect Yoshio Taniguchi designed. (New York, NY)

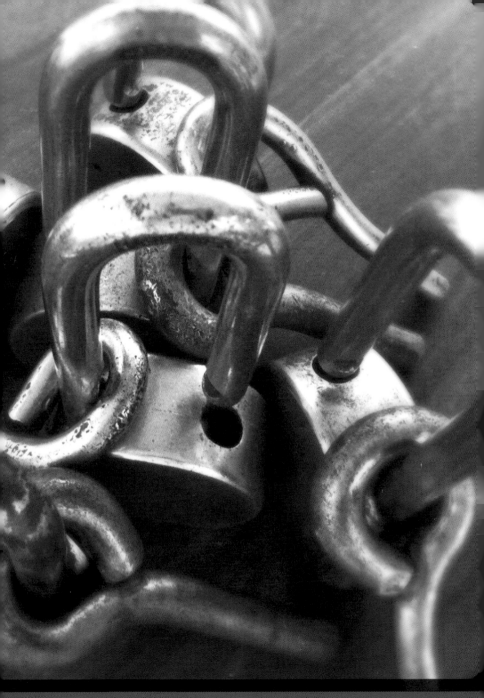

Locks This cluster of giant, heavy-duty metal locks securing roller shutters represents the typical security measures taken by owners of small neighborhood stores in Jersey City. (Jersey City, NJ)

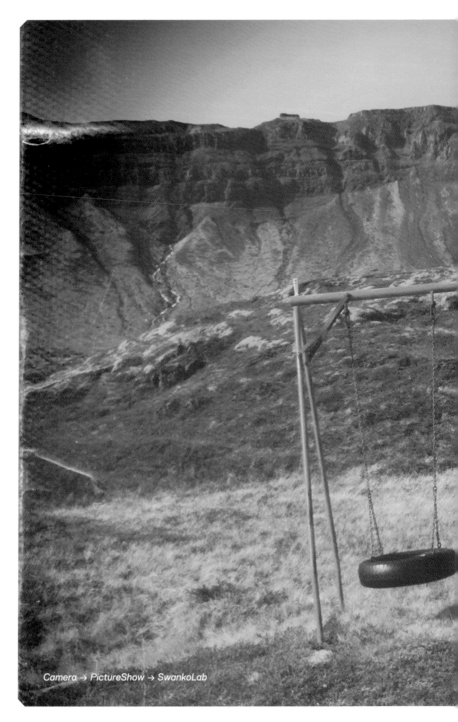

Camera → PictureShow → SwankoLab

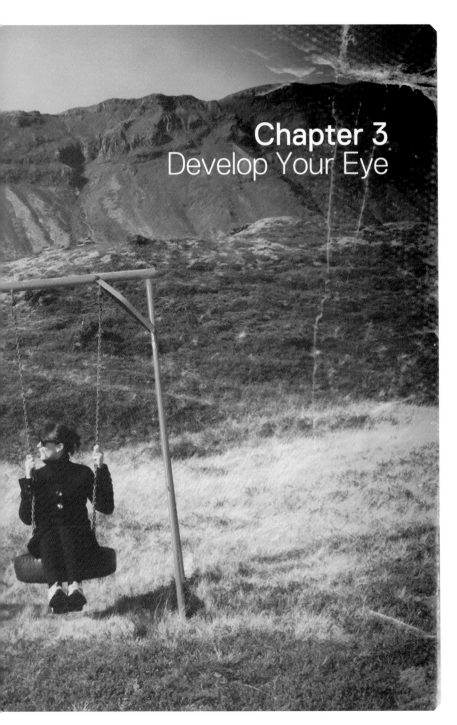

Chapter 3
Develop Your Eye

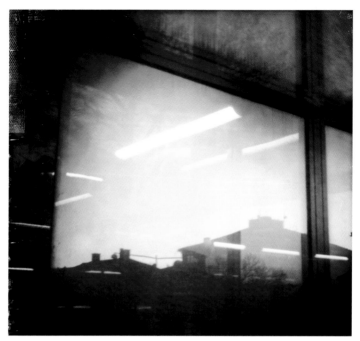

Hipstamatic

19 Take a look around

There's a difference between looking and seeing. Most things will pass you by without a trace if you're just looking at them without actually seeing them. Seeing requires you to reflect a bit on what you are looking at. When you're seeing, you allow yourself to discover your surroundings and find all the interesting things in your immediate environment and everyday life. You do it by studying things a bit more consciously, by processing your visual impressions a bit more critically. You simply decide to start seeing instead of just looking.

And once you've started seeing, you will almost automatically turn that photographic eye on. Your senses will become more receptive to everything around you, and you'll discover many new subjects.

Many people take pictures only during holidays and travel. That might be natural, but they miss all the interesting subjects in everyday life. Life doesn't really include many holidays, and there are a whole lot of ordinary days in between.

That's why it's often so interesting to shoot things that aren't staged or glamorous. Try to find subjects that are interesting despite being ordinary. Maybe it's your sleeping significant other (a little mean), your sleepy children at breakfast, your boss with his tie coming undone, a weird dog on the street, or your own face when you're feeling a strong emotion. You're free to choose your subject, and only you can determine whether what you see is worth documenting.

20 Try a theme

A good way to practice using your photographic eye is to give yourself small but clear-cut assignments. For example, try to shoot a given theme for an entire day. This will make you search for new subjects with an open mind. Why not let the theme of the day be dramatic shadows? When you search for subjects, you'll probably discover dramatic shadows that you normally would have passed by without even noticing.

In the fall, the sun is low in the sky. Shadows are long and full of drama. They can appear on house walls as threatening creatures or create drama in your portraits. Your surroundings might look boring with the short shadows cast by the midsummer sun. But on a late October afternoon, that very same place might be transformed into an amazing scene.

Hipstamatic → Best Camera

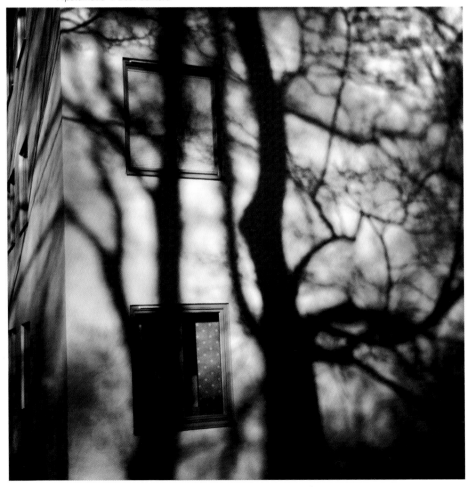

21 Empty space

Here's another suggestion for a theme that's almost always rewarding. In simple images, your eyes will quickly find the point of inter-est, so try to remove everything unneces-sary in your image. Your main subject will appear to be even more in focus. You can also use empty space to create a feeling of loneliness or vulnerability.

Try to avoid making your empty space too dead or boring. Let the light fall on your main subject, leading the eye toward it. Or darken parts of your empty space with an app like *PictureShow*, which can make the edges of your photo darker.

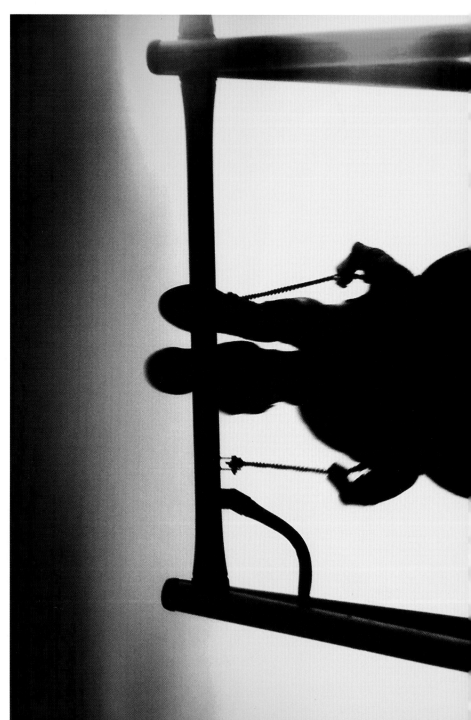

Camera → Plastic Bullet

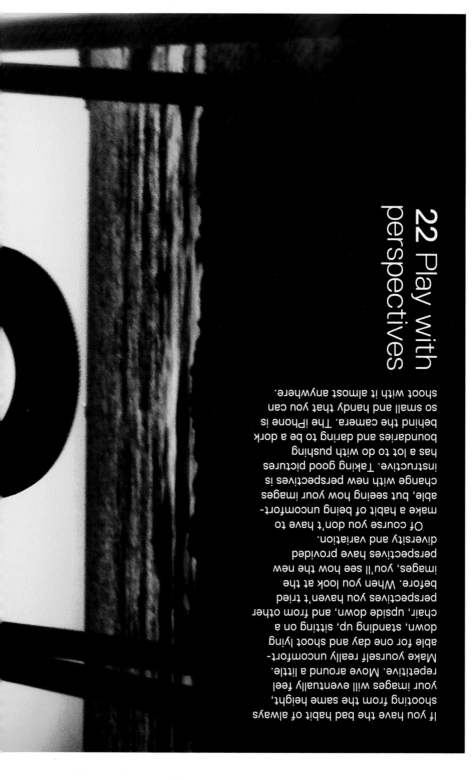

22 Play with perspectives

shoot with it almost anywhere.
so small and handy that you can
behind the camera. The iPhone is
boundaries and daring to be a dork
has a lot to do with pushing
instructive. Taking good pictures
change with new perspectives is
able, but seeing how your images
make a habit of being uncomfort-
Of course you don't have to
diversity and variation.
perspectives have provided
images, you'll see how the new
before. When you look at the
perspectives you haven't tried
chair, upside down, and from other
down, standing up, sitting on a
able for one day and shoot lying
Make yourself really uncomfort-
repetitive. Move around a little.
your images will eventually feel
shooting from the same height,
If you have the bad habit of always

23 Exciting shapes

Exciting shapes are everywhere: a close-up of a steamy window, texture on a house wall, a cheese sandwich, rust on a barrel, a close-up of a plant. Why not take a look at the souring milk in the kitchen sink? Move in really close when you shoot that glass of water. Then try the *Hipstamatic* app and its "Dreampop" effect, which creates a dreamy blaze of color. Or try the *Infinicam* app. Most things can be turned into exciting shapes. It all depends on how you shoot them and what you do with the pictures afterward. Only you can set the limits.

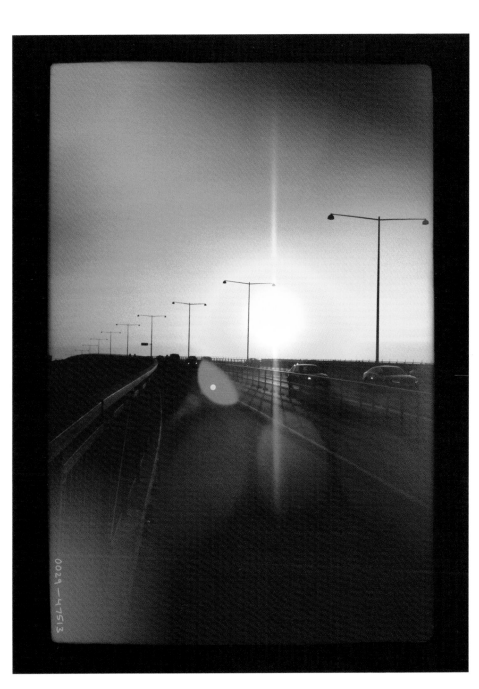

24 Create depth

It's pretty easy to create depth so that your image appears more three-dimensional. Divide your scene into three planes—foreground, subject, and background. In the final image your eye will move between the planes, from the foreground to the subject to the background. This is a good approach when you find yourself in dull surroundings and see something you just have to shoot. To create some depth you can hold something colorful close to the camera. It can be a scarf, a flower, or whatever you have on hand. The colorful object will provide an out-of-focus foreground that frames the subject and creates the illusion of depth in your image. You can also look for parallel lines that lead the eye into your picture. A street, a sidewalk, or a fence may serve this purpose.

Camera → Infinicam

25 Shoot from the hip

A fun way to find new perspectives is to shoot without looking at the display. By shooting from the hip you'll get unexpected results and exciting angles that can create the feeling of something captured on the fly. Images shot this way are often blurry, skewed, and unpredictable. Many of them will be unusable. But perhaps you'll strike gold with a few of them—images that make you think outside the box. Often, you'll find new angles that you'll start to seek naturally when you shoot. I suggest turning off the sound (with the Ring/Silent switch on the side of the iPhone) and firing away from any and every weird angle for a whole day. How do those images differ from the ones you normally shoot? Are there new perspectives that you wouldn't have thought of if you had shot with an eye on the display?

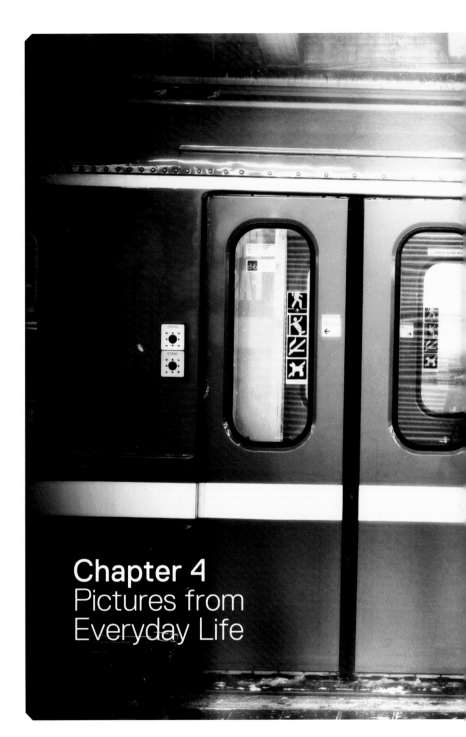

Chapter 4
Pictures from
Everyday Life

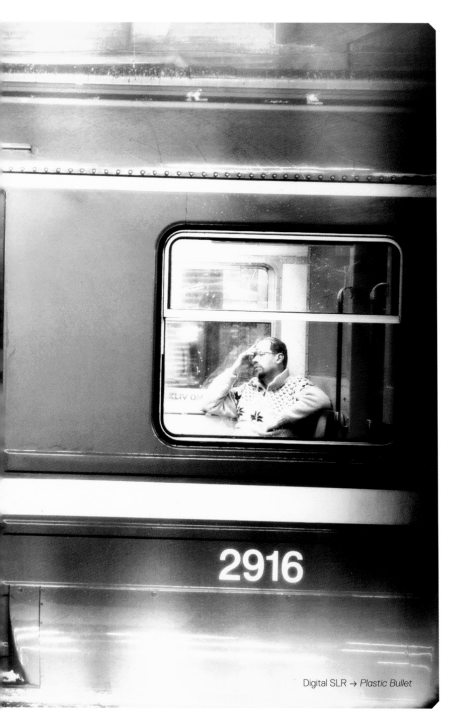

2916

Digital SLR → *Plastic Bullet*

26 Snapshots

Hipstamatic

The concept of *snapshots* was promoted by film and camera manufacturer Kodak back in the year 1900, in connection with the release of the company's Brownie camera. It was a box with a shutter release button and a crank to advance the film. That was all—and that was enough. The Brownie was a success.

Suddenly it was possible to take pictures instantly—simple images of everyday life, just for the sake of remembering—without having to worry about shutter speeds, f-stops, film sensitivity, or film processing and printing. The tagline was "You press the button, we do the rest." The moment was in focus: your vacation, your family holidays, or just the mood set by the fluttering curtain in the window.

Technical development during the twentieth century was explosive. A steady flow of new camera models hit the market, accompanied by killer commercials, and we happily let ourselves be carried away. We bought new camera bodies, cooler lenses, flashes, and tripods. And filters, and … Well, we tried to follow the trends, and we took the best pictures we could with all our fancy stuff. But now all that stuff is in a cardboard box up in the attic.

Now, more than 110 years later, we come full circle.

Take your iPhone out of your pocket.

What were we talking about? Snapshots! Simple images of everyday life, just for the sake of remembering. Do you see that curtain fluttering in the wind?

Hipstamatic with the "Dreampop" effect

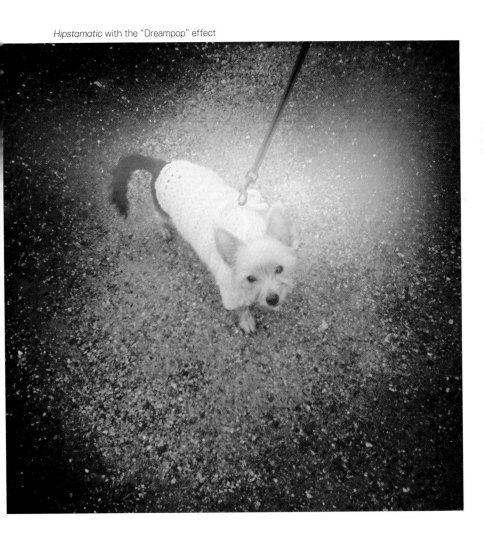

27 Freezing commuters

What could be more boring than congestion among commuters on an early morning in November? Well, you could make things a bit more interesting by trying to capture the mood with the camera on your iPhone. Shoot sleepy passengers, hollow and empty winter gazes, congestion, and movement. Take out your camera and capture your fellow passengers on the bus, in the subway, or on the streetcar. But show some respect, and always ask for permission before taking any kind of close-ups. That boring November morning will suddenly become fun to relive when you look at your images later back at home.

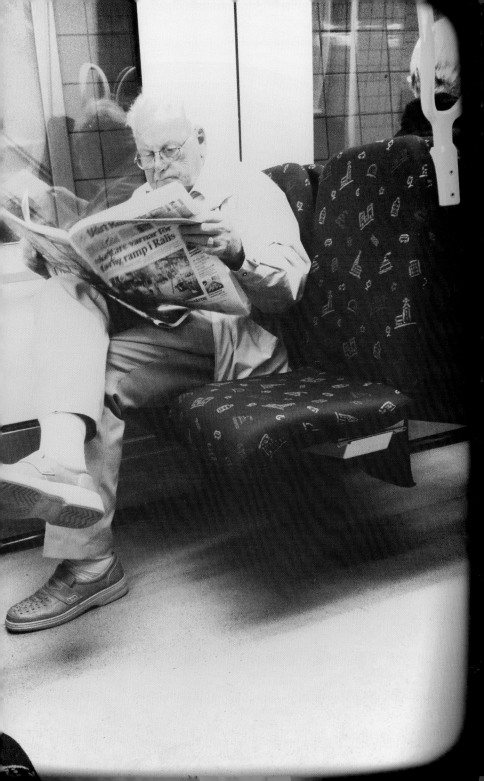

I shot this image series in part with my DSLR and in part with my iPhone via the *Plastic Bullet* app. To get the same look and feel in all of the images, I transferred the photos taken with the DSLR to my iPhone via iTunes (see tip 10) and applied *Plastic Bullet* to them.

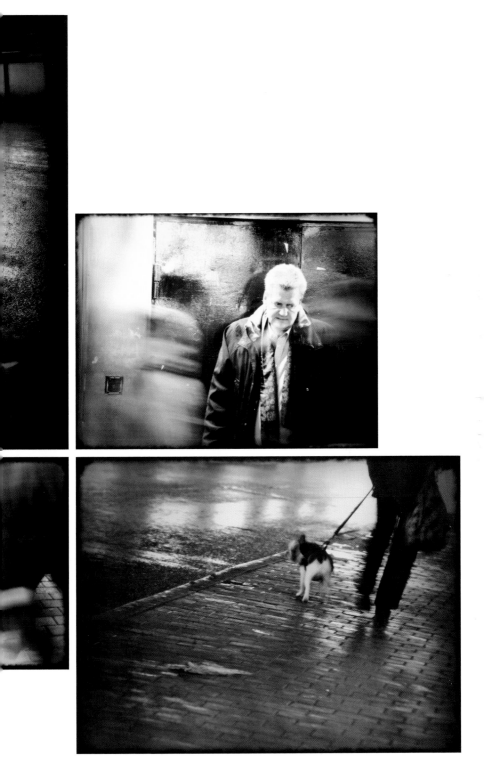

28 All in a day's work

Photographing your workday is a fun exercise. Torment your colleagues by taking pictures at meetings, in the cafeteria, and on the factory floor. You can also put your iPhone to practical use by shooting presentations at meetings, saving you time because you won't have to take notes by hand. The *CamScanner Free* app works great for that, and it's also good for straightening any slanted lines you may get in your picture. For example, if you shoot a whiteboard from an angle, you can use the app to straighten the angles afterward. You can also increase the contrast to improve the clarity of the text.

Camera → Plastic Bullet

29 Seek out those ugly subjects

Beautiful subjects can look glorious in pictures, but sometimes you can have too much of a good thing. Our world isn't all beautiful, right? So why portray it like that? Instead, seek out the ugly. There are so many absurdities to discover in the world. Deciding to shoot only ugly subjects for a day is fun and will give your creative side an outlet. What is considered ugly is of course entirely up to you.

30 Photograph your friends

The *Hipstamatic* app is great for pictures of friends and relatives. It gives you that nostalgic feeling that goes so well with old memories you want to keep. The images it takes come out like diary-style snapshots. Your iPhone also has a shrewd self-portrait feature. Just press the camera symbol at top right in the *Camera* app and the app will switch the camera so that it faces you. Take a picture of yourself, or of yourself and a friend, and share the picture on blogs or on Facebook.

The yellow "Dreampop" flash effect enhances the image and creates a nice contrast with the green color tone. These are the kind of unexpected results that make it so fun to take pictures with an iPhone. The images often turn out a bit "wrong." Because the flash lacks settings for exposure, the face just happened to disappear. The unexpected results give the image a liberating feeling of playfulness.

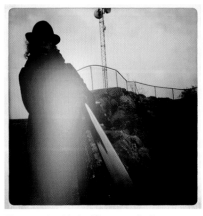 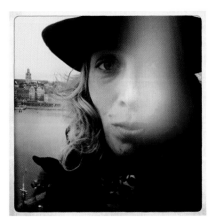

Hipstamatic with the "Dreampop" effect

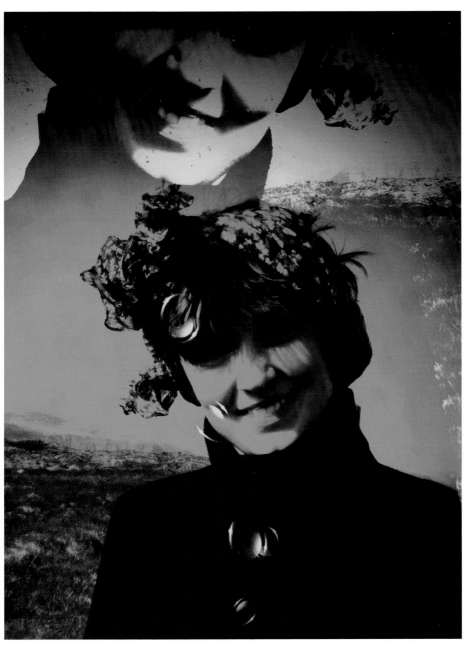

Camera → PictureShow

8 1 0 0 4 7 3

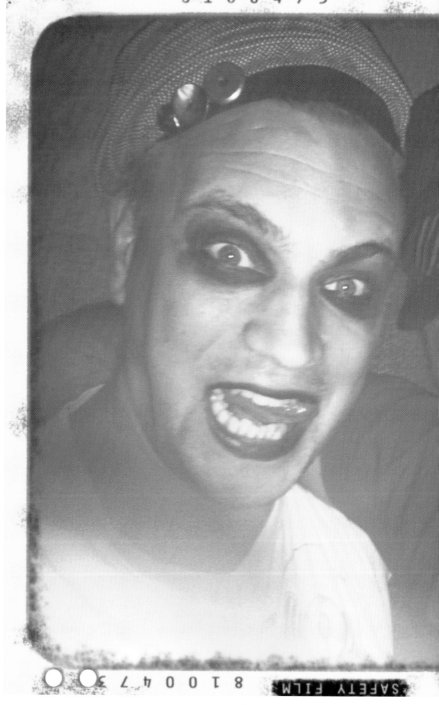

31 Party pictures

Of course you should bring your iPhone to the party. As a small camera, it's perfect for taking spontaneous, lively party pictures. And there are lots of fun apps for boosting the party atmosphere in your pictures. For example, try *Plastic Bullet* to give drinks extra strong colors, *IncrediBooth* to create fun photo strips, or *Instagram* to get an immediate view of what your friends are shooting with their cell phone cameras. Another fun app is *Wig Booth*, which allows you to photograph people at the party and then dress them up in awesome wigs or magnificent mustaches. If the party is boring, you can entertain yourself by swapping people's faces with *iSwap Faces*. And remember to make video clips. In chapter 7 you'll learn how to get started with videos.

Camera → Infinicam

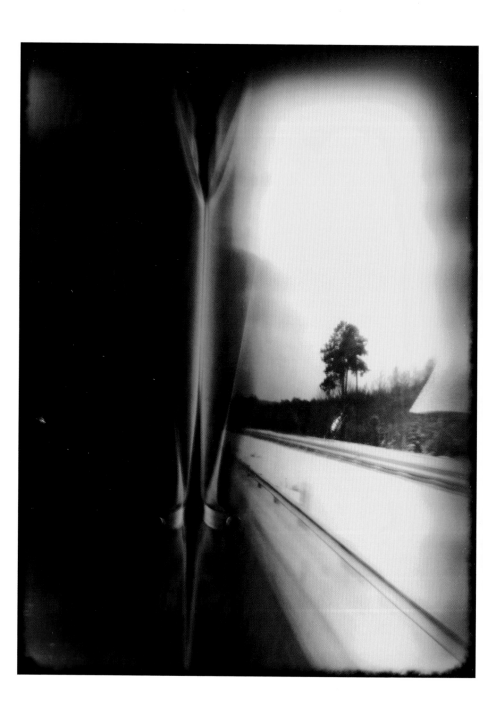

32 Evening and dusk

Have you tried to shoot a portrait with your iPhone when it was a little too dark? It doesn't really work out, and the built-in flash is of little help. Pictures come out flat and the subject ends up with red-eye. Despite that, you can have fun with your iPhone camera even during the evening.

Forget about people for a while. Instead, shoot environments like buildings and landscapes. Cityscapes at dusk, just when the streetlights come on, can turn out looking fantastic. The sensor in your iPhone is relatively sensitive to light, so pictures taken in that setting will come out pretty well. Because there is no tripod socket on the iPhone, you might have to accept a little camera shake. It might even intensify the mood in your image. If you get too much shake, try holding your iPhone steady while stabilizing yourself against a railing, a lamppost, a bench, or any stationary object you can find.

This image was taken through a bus window. The sun was setting and the bus was moving. Despite that, the image is relatively sharp. I like this type of snapshot, captured on the fly. It's a pretty mundane image, but it captures something valuable in that particular moment.

33 Snow

Winter can make it hard to take good pictures. Bright snow throws automatic exposure systems off. Either the snow comes out like white, featureless blobs, or it comes out like a dirty gray blanket. But it's not just because of the automatic exposure. The range of light in a winter landscape can be so great that the camera's sensor just can't register all tones, from the darkest to the brightest. The highlights will be overexposed and featureless, or the shadows will be underexposed and featureless.

Your iPhone can save the day with its built-in HDR (high dynamic range) function (see tip 5), found in the *Camera* app. When you turn on HDR, your iPhone takes several images at different exposure settings in quick succession. Then it combines them to create a final image showing a broader range of tones. Suddenly, you can capture all the beauty in a crisp winter landscape, even when it's cold and the snow glitters like crystals on the tree branches. Winter-walk checklist: mittens, warm hat, iPhone.

To get details in both highlights and shadows, I shot with the regular *Camera* app and turned the HDR function on. Then I used the *Plastic Bullet* app to enhance the cold, blue feeling.

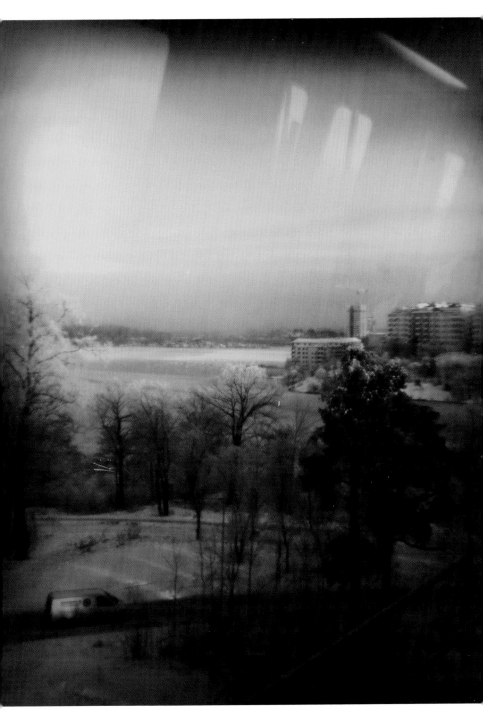

34 Details

A common beginner's mistake is to shoot
from about the same distance every time.
You miss all the exciting details you'll dis-
cover when you move in close. Luckily, you
can get really close to your subject with an
iPhone and still get sharp pictures that are
rich in detail. Try to create an interesting
image series by varying your distance and
giving extra attention to important details.
Images of details are often nice to look at,
and they will constitute an important dim-
ension of your series. In an image series
from a wedding, you may want to include a
close-up of the rings, the bridal bouquet,
and the table setting. In a portrait series,
you may want to show a tattoo or some-
thing else that's unique to the person
portrayed. The truth is in the details.

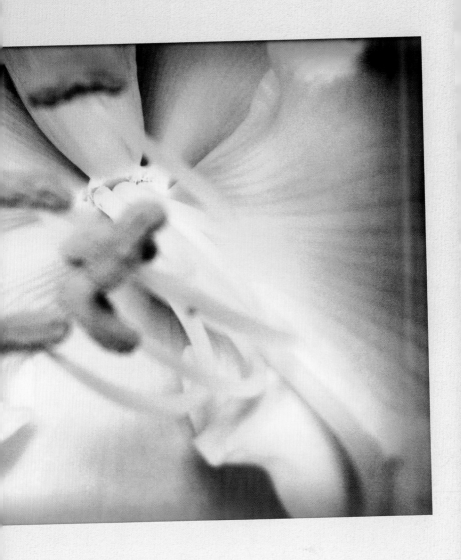

12.25. 2010

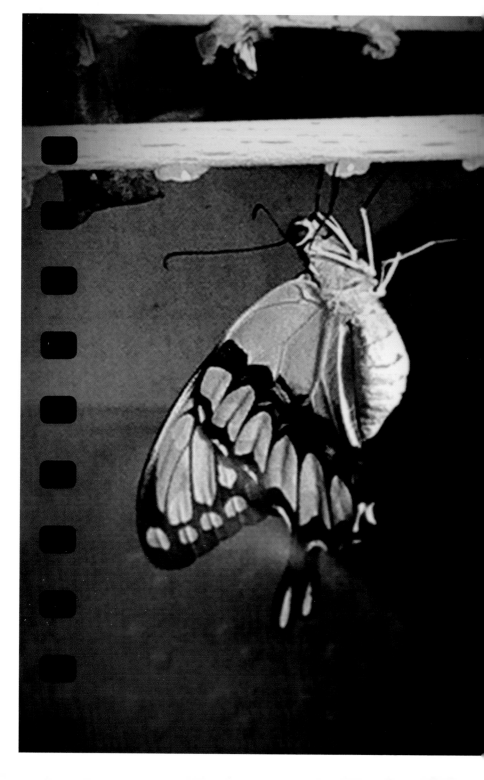

35 Picturesque images

Do you have artistic dreams? Then it's time to make them come true. You no longer have to worry about getting oils, canvas, and an easel to create a picture that looks like a painting or a drawing. Many of the photo apps on the market are excellent replacements.

And who says you need to be able to make out what the picture portrays? The important thing is that you like it, and that it conveys a feeling that appeals to you.

With the *Picture Effect Magic* app you can easily transform your image into an oil painting. With *TOUCHUP STUDIO* you can add textures and patterns, and *PictureShow* has effects that make your images look like Pop art by Andy Warhol. Why don't you print your piece of art and frame it? Don't forget your signature in the corner.

36 Black and white

If you want to accentuate shape, texture, shadow, and light in a subject, you can convert your image to black and white. In a black-and-white image the subject appears finely sculpted, and the photograph often feels more focused than the corresponding color image. Another advantage is that you can experiment with light without regard to colors. Moreover, it's easier to make a series of images function as a group. If you like black and white, it's a good idea to use apps especially made for that. *Hipstamatic* has an effect called "BlacKeys SuperGrain Film," which simulates old black-and-white film. It produces a nice range of tones, from black to white. The apps *OldCamera*, *Bad-Camera*, *Noir Photo*, *Dramatic Black & White*, and *TtV Camera*—to name a few—can also produce nice results.

Camera → Lo-Mob

Hipstamatic

Chapter 5
Go for It

37 Play!

Right and wrong—those words don't belong in the creative arts. And the rules you encounter are meant to be broken. Does it really matter how much you're allowed to manipulate a photograph before you have to call it something else? It's best to create freely, without bounds. Everything goes, as long as you're honest about what you do. So do what's fun and feels right to you. The only one who can stop you from pushing the envelope is yourself. Your images will get so much better and more interesting if you disregard what's considered acceptable and "right."

Hipstamatic

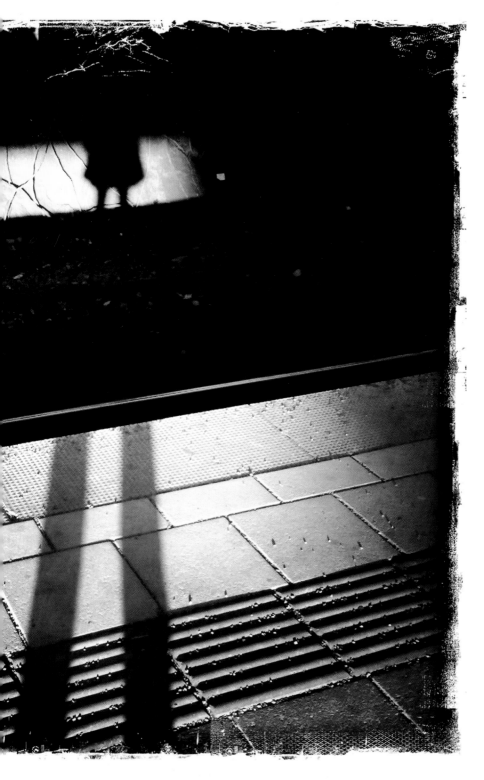

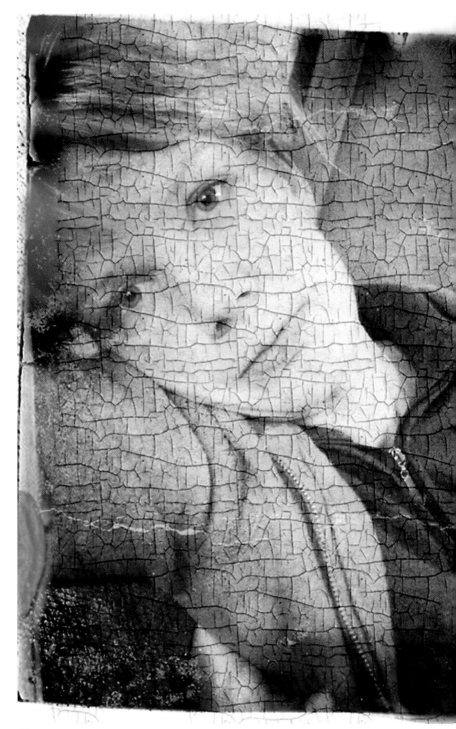

38 Combine apps

A disadvantage with many apps is that they can make images a bit impersonal. One example is *Bad-Camera*, which has a host of interesting effects to choose from. The problem is that the scratches, thumbprints, and dirt always appear in the same place in your images. As a consequence, your photos will start looking more and more alike. A trick you can use to create a more personal expression is to apply a combination of apps to the same picture. Your picture will feel more personal, and it won't be as evident which apps you've used.

39 Spontaneously beautiful wedding pictures

Shooting a wedding requires timing, precision, and quite a lot of equipment. That's why the job is most often done by a professional. But you can shoot with your iPhone during the ceremony, and create an unusual slideshow of spontaneous pictures. An iPhone produces relatively small pictures that are best suited for the web, small prints, or (you guessed it) slideshows. So bring your iPhone to the next wedding. Shoot anything you find interesting, add exciting effects, and create a unique slideshow as a gift to the newlyweds.

Digital SLR → *Instagram*

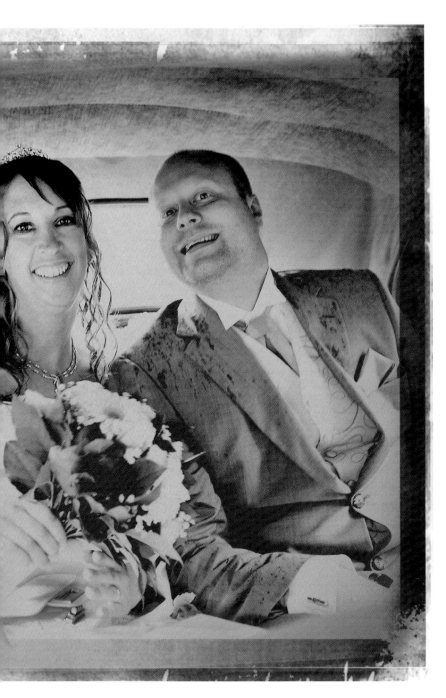

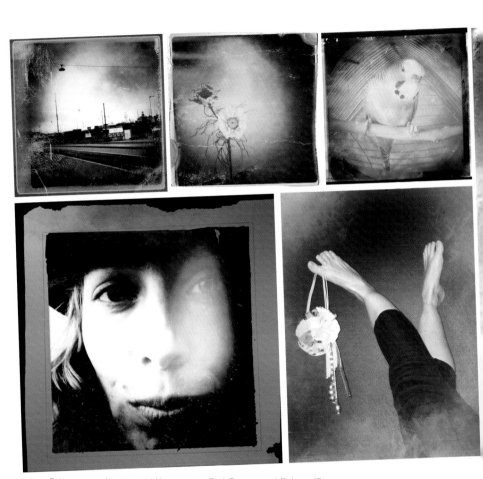

Different combinations of *Hipstamatic*, *Bad-Camera* and *Fisheye4Free*

40 Find the shoebox feeling

What makes an image interesting? Historically, we have assessed properties like light, color, content, and composition. Deeper issues include message, symbolism, and theme. But today it seems like we more often—perhaps through pure laziness—look at technical aspects like sharpness, correct color reproduction, and perfect exposure. Perhaps it's because modern digital cameras have set a whole new standard for technical perfection. Have we reached the point where we routinely dismiss pictures

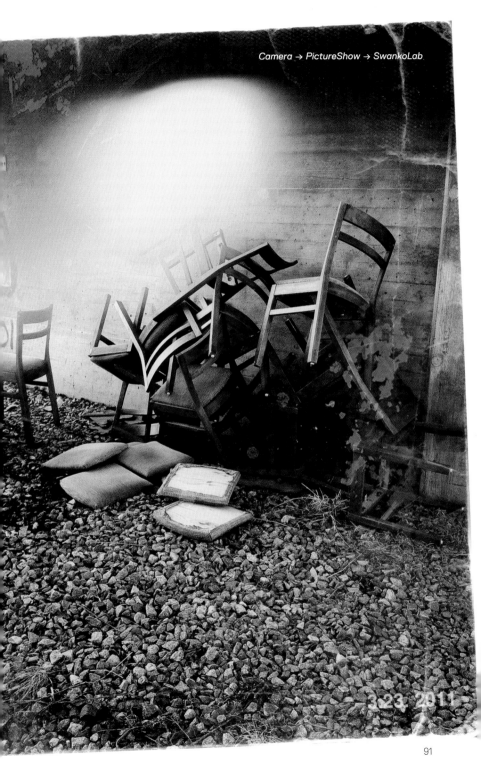

3.23 2011

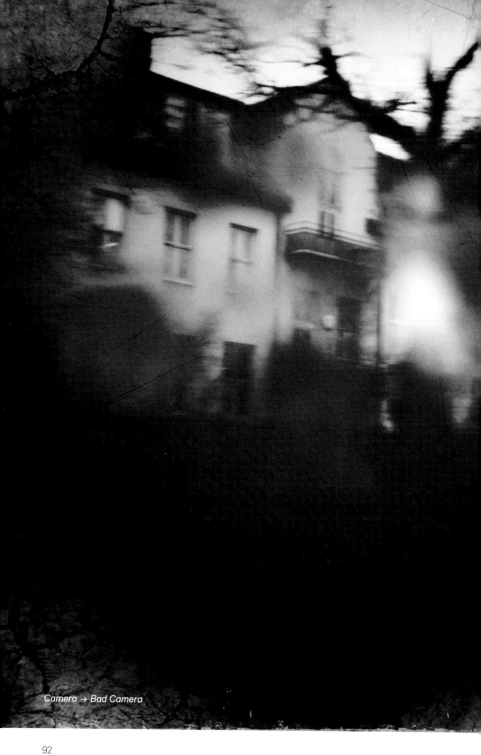

Camera → Bad Camera

Camera → *Plastic Bullet*

that don't measure up technically? Maybe we lost something in the transition from film to digital. Did we lose in artistry and expression what we gained in simplicity and technical perfection?

Whatever may have been lost you can now regain with your iPhone. There are a lot of apps that give you the dirt, light leaks, dust, and scratches typically seen on old film. It may sound weird to use a super-modern, digital cell phone camera to create dusty, scratched images. But the point is that it gives you the opportunity to concentrate on artistic expression, on the fun and creative, on your creation. Let go of all preconceptions that images are supposed to be technically perfect. With your iPhone and a suitable app you can recreate the effects of film, chemicals, and a darkroom with the push of a button. It's time to create.

41 Panoramas

Do you like pictures that are really wide but not too high? Then you have to try *AutoStitch*. It's an app that lets you create really stunning panoramic shots. Stand in the spot from where you'd like to shoot, and slowly rotate your upper body from one side to the other, pausing at regular intervals to take a picture. A smooth panorama requires the images to overlap a bit. The app combines your image series to create a single panorama.

Camera → AutoStich

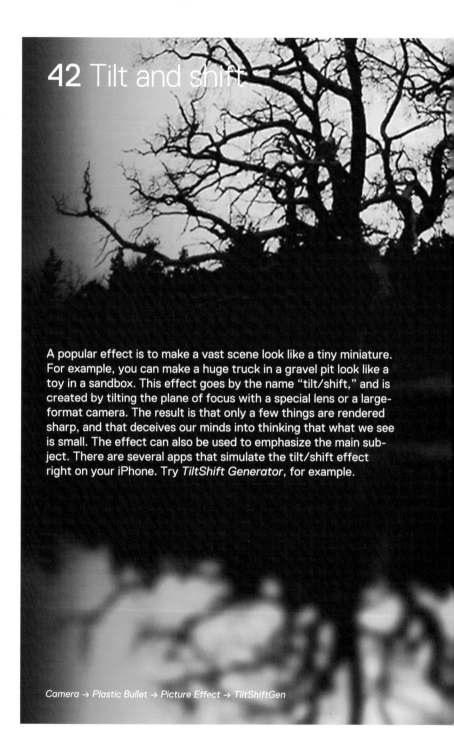

42 Tilt and shift

A popular effect is to make a vast scene look like a tiny miniature. For example, you can make a huge truck in a gravel pit look like a toy in a sandbox. This effect goes by the name "tilt/shift," and is created by tilting the plane of focus with a special lens or a large-format camera. The result is that only a few things are rendered sharp, and that deceives our minds into thinking that what we see is small. The effect can also be used to emphasize the main subject. There are several apps that simulate the tilt/shift effect right on your iPhone. Try *TiltShift Generator*, for example.

Camera → Plastic Bullet → Picture Effect → TiltShiftGen

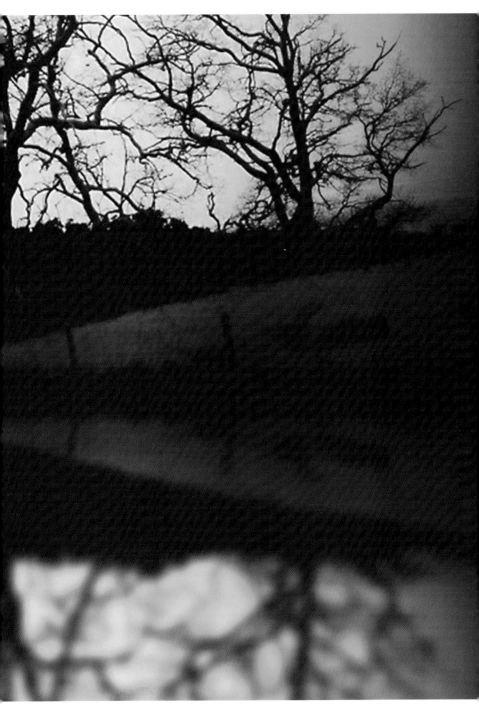

Camera → OldBooth

43 Style is everything

When you want to get all goofy and take really weird pictures, your iPhone is perfect. There are a bunch of apps that can be of help for your most far-out projects. One example is *OldBooth*, which you can use to alter your

Camera → OldBooth

friends' faces, swap their bodies, distort the proportions of their faces, and dress them in wonderful wigs from the eighties. Do you dare to put the images on Facebook? There's always a risk that your friends will retaliate with even weirder pictures of you.

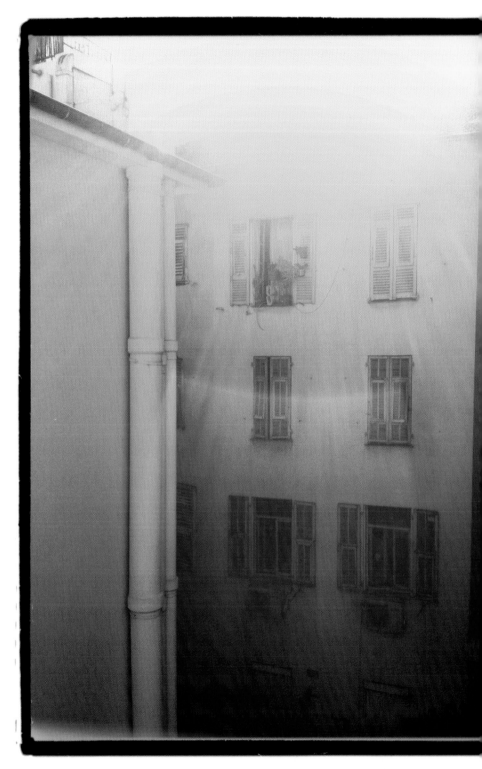

44 The light

Photography is all about light—or so they say. And of course they are right. It's light that creates mood, sculpts form, and provides character. So when the light changes, your picture changes. What time of day are you supposed to shoot? What time of the year? Well, it depends on what you want to show. Mastering light is perhaps the single most important skill for a good photographer. Some professionals say, "The less light, the better the image." What they mean is that you should use light sparingly and let it shine primarily on your main subject.

But if you think all that sounds complicated, you can cut a few corners. With your iPhone and a few apps you can easily create interesting light. Many apps adjust the light in your picture and transform it into a mysterious and suggestive piece of art. Perhaps this is the best thing about apps. They can make an image more than just a photo, thanks to lighting effects that accentuate the mood. It's best to shoot as usual with your iPhone first, and then add exciting effects with your favorite app afterward. When you're done with your image, compare it to the original. Which one do you like better? Can you explain why?

Camera → PictureShow

Camera → Plastic Bullet

It's often best to shoot with the regular *Camera* app then add effects with the apps of your choice. Compare the original to the edited image. Which one do you like better? Why? What creates the mood in the image? How does the light fall? How is the image affected by the effects you added?

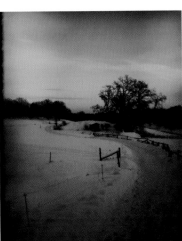
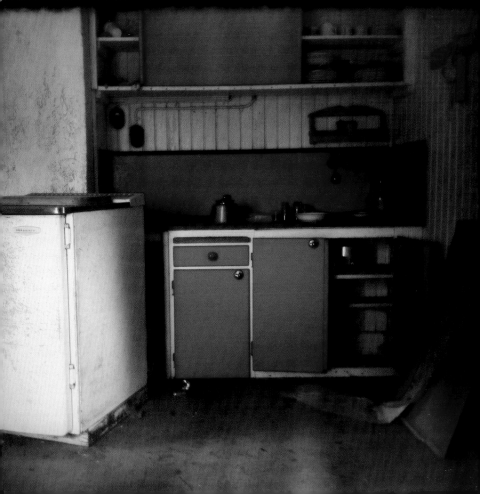

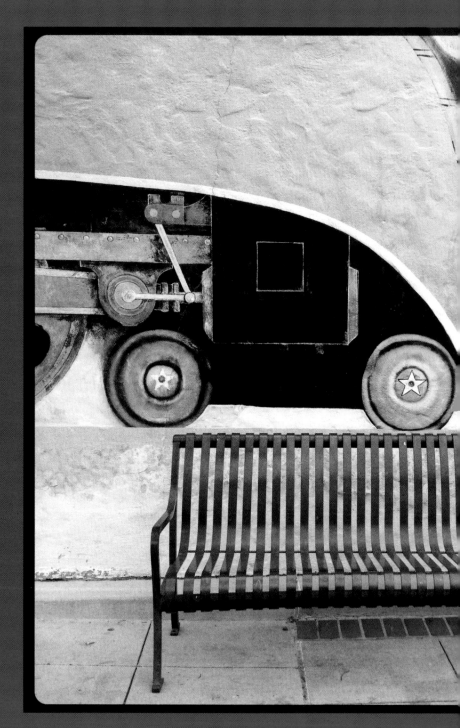

Bench

Guest Gallery
Bettina & Uwe
Steinmüller

Grunged Truck

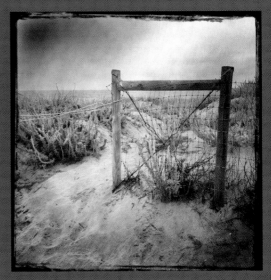

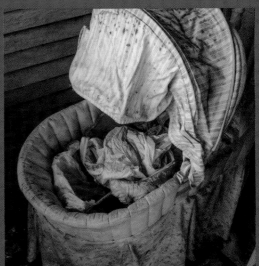

Moss Landing Dunes (top)
Where's the baby? (bottom)

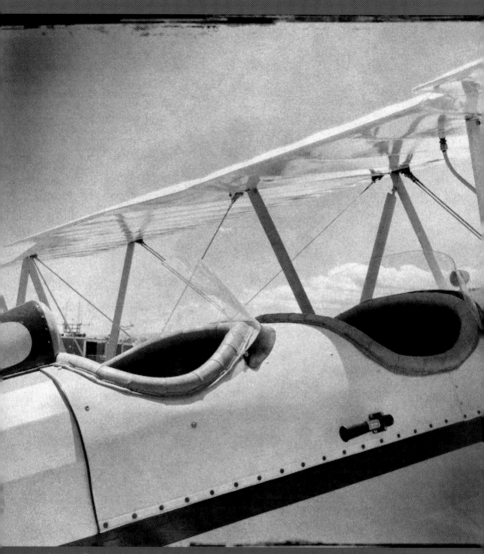

Airshow Biplane

German photographers Bettina and Uwe Steinmüller came to live and work in the United States over a decade ago. Bettina and Uwe concentrate on taking photos to create fine art prints, mainly nature and urban landscapes. In the past, their images often had a painterly look, although they were not treated for this effect. For a number of years now, they have used HDR and texture blending to enrich photos. They enjoy experimenting with the iPhone to explore its creative potential.

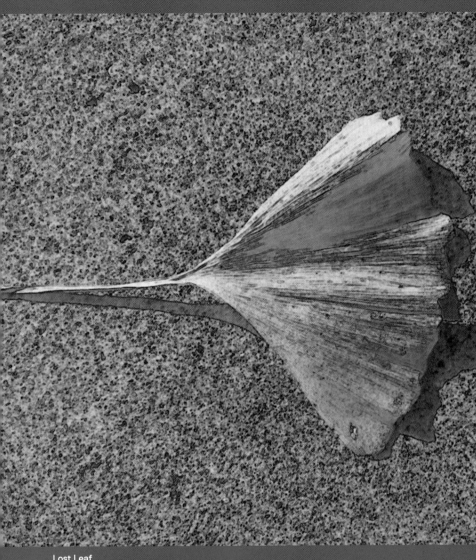

Lost Leaf

Uwe is the owner and editor of Digital Outback Photo. One major focus of Outback Photo is the digital workflow, and Uwe has authored numerous books about this topic.

The images in this gallery are from Bettina and Uwe's e-book Phone Artistry 2012 VI: The Art and Craft of iPhone Photography, which can be found on the Digital Outback Photo website.

More from Bettina and Uwe Steinmüller
www.outbackphoto.com
books.outbackphoto.com/PhoneArtistry.html

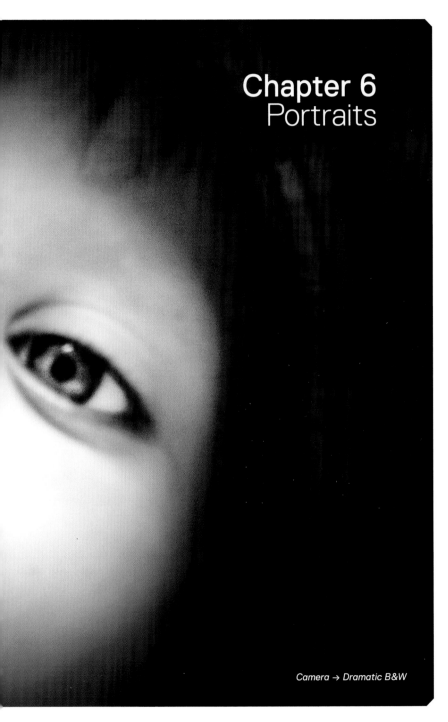

Chapter 6
Portraits

Camera → Dramatic B&W

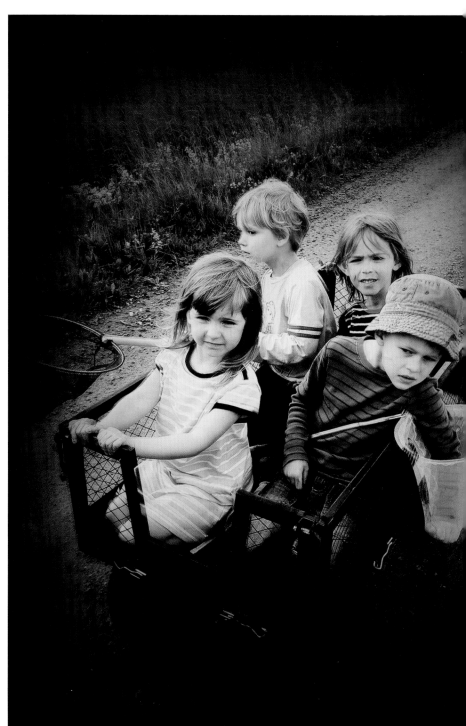

45 Capture the secret

Good portraits are often characterized by the photographer's ability to capture beautiful light, an interesting expression, or a captivating gaze. If you're able to capture all three of those elements in your portrait, then you're ready to compete with masters like Irving Penn, Richard Avedon, and Annie Leibovitz. Even though the level of the masters might seem out of reach, it's fun to practice and learn at your own level. And for that, your iPhone is perfect.

Look carefully at some portraits you admire and analyze how well the photographer has been able to capture the three elements: light, expression, and gaze. Take out your iPhone and try to put your new insights into practice.

46 Develop your courage

Sometimes we meet people we would like to photograph. They radiate something very special—an expression, a style of clothing, or perhaps a behavior we just have to capture. But most of us are content with that thought, the observation that *here is a fantastic image*. Because you can't really take pictures of people you meet on the street, can you?

Well, actually, you can. But if you want to take pictures of perfect strangers, you'll have to expose yourself to situations that many of us consider uncomfortable, and that requires a little courage. So here's a tip for next time you see someone you want to take a picture of: Do not think about it being uncomfortable to ask permission. Instead, *do* think about how much you'll regret it if you don't even try to capture that amazing image you see in your mind.

Try summoning your courage and approaching the person you want to shoot. Introduce yourself, and compliment the person's clothes or something along those lines. Chat a bit. Then ask politely for permission to take a picture or two. The person might actually say yes. Right? And then you get your picture. Should the person say no—well, at least you tried.

47 A pocket photo booth

Camera → IncrediBooth → SwankoLab

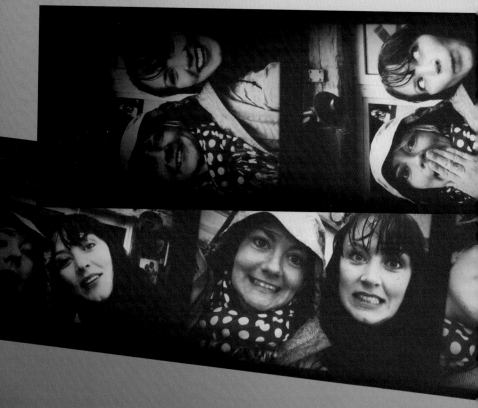

Do you remember the old photo booths? They were common back in the days when the digital era was still a bit in the future. Outside the booth was a mirror for those last-second appearance checks before you sat down on the rotating stool behind the curtain and waited for the four flashes. Often you squeezed a couple of friends into the narrow space and hoped for some fun pictures. After four or five minutes the pictures appeared as a four-image strip. If things worked out for the best, you weren't blinking in all the pictures.

Now you can relive those photo booth memories with the app *IncrediBooth*, which offers four different effects. The app is great fun for people who want pictures of themselves and their friends in that nostalgic style. The shots are fired in rapid succession and the result is a strip with four pictures in the old passport style. Send the strip to your friends by e-mail or MMS.

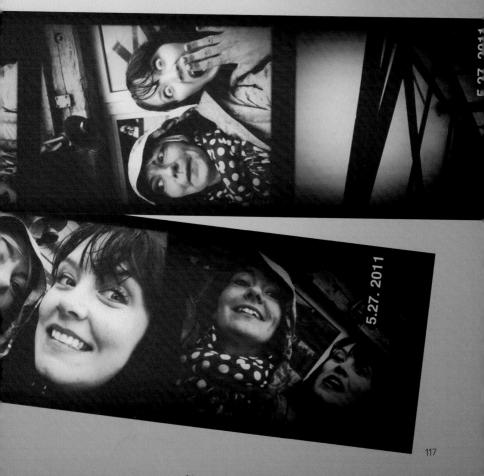

Camera → Lo-Mob → SwankoLab

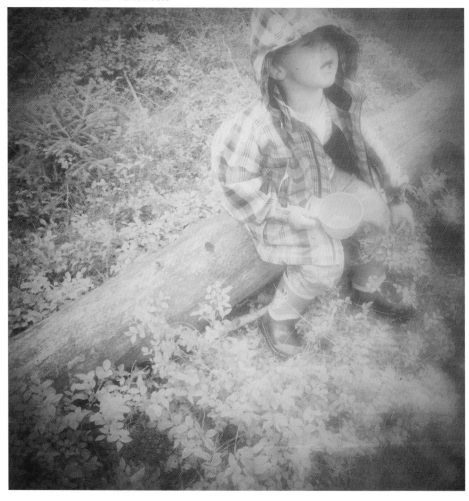

48 Young as well as old

If you like how a typical photograph looked a hundred years ago, there are many apps you'll love to have on your iPhone. With the *Old Photo Pro* app, you can give your image that antique photo studio look. With *Bad-Camera*, you can achieve an old and ruined look. Revel in ugly thumbprints, stylish frames, dust, scratches, and light leaks. The app gives you exactly what its name indicates— images with a worn, faded look. If you'd like to create a dreamy mood with a touch of sadness, then *Bad-Camera* is your best bet. Try changing your profile picture on Facebook to one in an antique style. You could wear an elegant hat from the twenties, an eyeglass, or something else from that same era.

49 Take a picture every day

Taking a picture of yourself every day for an entire year and combining the pictures to make a movie is an old photographic technique you can use with your iPhone. The *Everyday* app provides a fun and simple way to try the technique. Just take a picture of yourself every day and the images will be displayed as a slideshow that lets you follow how your face changes with time. The app even sends you a reminder each day. To ensure that you shoot from about the same angle and distance each

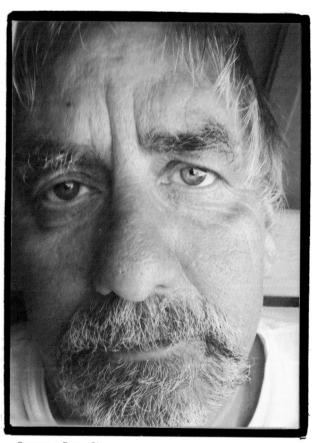

Camera → PictureShow

time, the app shows you a faded version of yesterday's picture. It's a good idea to photograph yourself immediately after you get the reminder, and do it no matter what. This gives you an honest, although perhaps not very flattering, series of pictures that can be interesting to watch later on in life. You could also use the app to document an infant's very first year. The resulting slideshow will become a memory for life, for both you and the child.

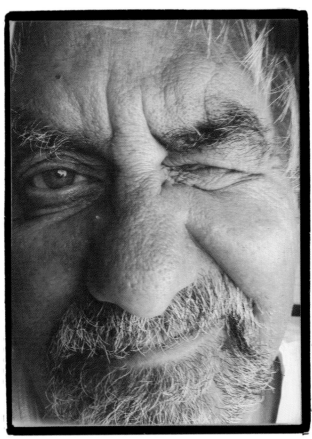

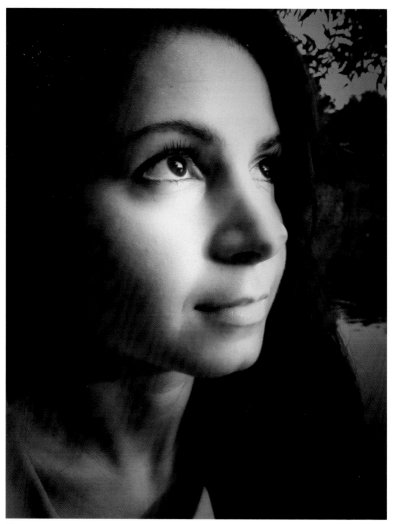

Camera → FaceCam → Noir

50 Beautiful, like a model

Perhaps you dream of taking beautiful, stylistically pure pictures of models, in which imperfections like acne, wrinkles, and blackheads are magically absent. Maybe you want one of yourself. Luckily, there are several apps that can help you beautify faces and skin. The apps *moreBeauté2*, *Virtual Makeover*, and *Face Cam* lighten and smooth the skin in your portraits. Tap the display a few times, and the skin in your picture becomes smooth as a baby's.

51 Graphic, like street art

There are apps that can turn your pictures into strong, graphic art. One example is *Photogene*, which offers effects similar to what you can achieve with *Adobe Photoshop*. The app includes a set of tools that make it easy to edit a picture. One idea is to transform an ordinary portrait into an interesting, graphic profile picture and use it on Facebook.

Camera → Photogene

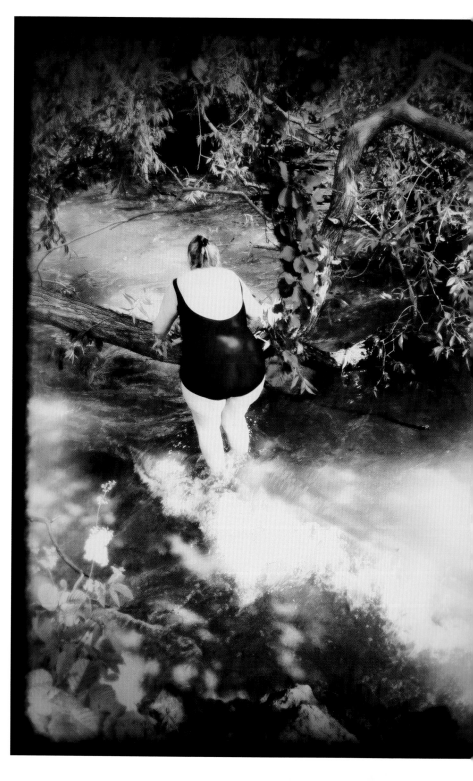

52 More vignetting

Vignetting means that an image gets darker around the corners and along the edges. It could be a problem caused by the construction of the lens or by the lens hood casting a shadow on the corners. But vignetting can also be a desired effect created, for example, in Photoshop to frame and draw attention to the subject. If you study newspapers, you'll see that even press photographers sometimes use this technique. By using the *Plastic Bullet* or *PictureShow* app, you can easily give your picture a nice vignette. Another alternative for the black-and-white photo enthusiast is the *Noir Photo* app. In addition to vignetting, it gives the picture much more contrast—and, of course, converts it to black and white.

Camera → Plastic Bullet

Hipstamatic

Chapter 7
Video Clips

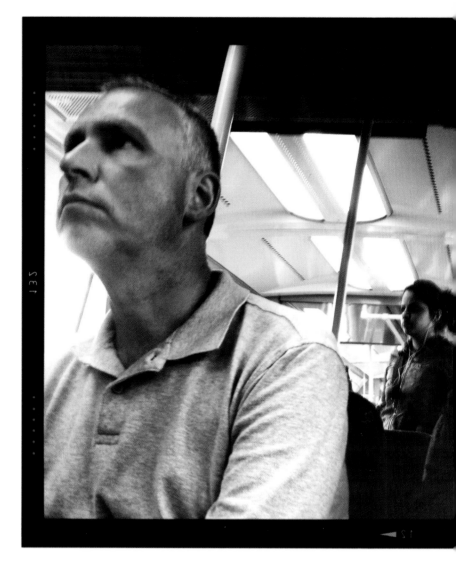

53 Record, play back, check it out

Video clips from sites like YouTube are increasingly common on the web. Amateurs as well as professionals record video clips with their digital cameras and share their clips on the web via social media. New technology has made it fun and easy to do so.

Your iPhone works perfectly for recording high-resolution video clips. You can upload your clips to YouTube directly from your iPhone.

However, making a truly good movie is hard and technically challenging. Light, sound, tempo, and story should all work in harmony.

One approach is simply to focus on getting the right feeling and let some well-chosen apps take care of all things technical. There's an abundance of apps for everyone who likes to shoot videos. And just like the photo apps, many of the video apps imitate old, scratchy movies. The effects they offer are fun and different. You can also edit your clips and share them on Facebook. In the following tips, you'll learn more about using your iPhone for video.

54 Trim those short clips

Rarely does a video clip turn out perfect right out of the camera. The first thing you might want to do to improve your clip is cut those unnecessary parts at the beginning and end. You can do that kind of basic editing with the standard *Photos* app.

The video clips you record with the standard *Camera* app are automatically saved among your regular pictures. Open your clip in the *Photos* app and touch the play button at the center of the display to view it. A white cursor will show the current position on a timeline at the top of the display (tap the display once if the timeline isn't shown). You can create new start and end points by dragging the sides of the rectangle that surrounds the timeline to the desired positions. Tap *Trim* when you're done. Choose to overwrite the old clip if you want to save memory. Choose to save as a new clip if you want to keep the original.

If you want to share your creation, you just return to playback mode and tap the share icon at bottom left. Choose between sending your clip by e-mail or text message and uploading it to YouTube. Fast and simple.

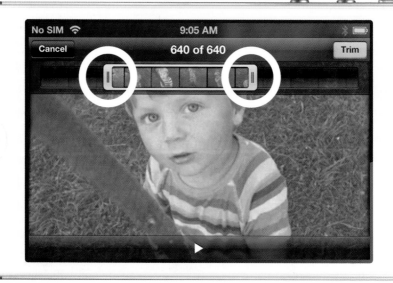

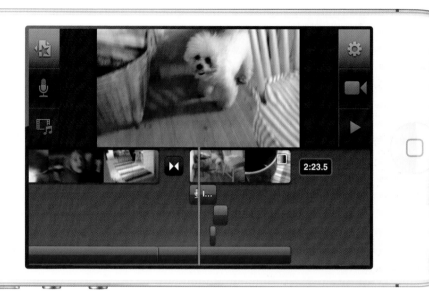

55 Edit a real HD movie with *iMovie*

The most basic type of editing is best done with the *Photos* app. If you'd like something more advanced, you can download the very capable *iMovie* app for just a few dollars. It turns your iPhone into a fully equipped video studio, which lets you work with text overlays, voice overdubs, sound effects, music, and elegant scene transitions. When you're done, you can upload your movie directly to YouTube, Facebook, Vimeo, or CNN iReport (should you wish to work as a CNN news reporter). Or you can save it as a high-quality clip to the regular Camera Roll for further editing in other apps (see the following tips).

Camera → Infinicam

56 Make an old silent movie

With the *Silent Film Director* app you can make nice silent movies with your iPhone—and even participate in a movie competition with a chance to win prizes. So why not put some effort into making a really super movie? The theme of the app is, of course, nostalgia. It lets you choose between styles like "20's Movie," "60's Home Video," and "Black & White." You can also add music, text overlays, and still images. You can create a fun effect by changing the speed and making the movie run too slow or too fast. With this app, you can let your imagination run wild. Making a silent movie is simple and fun. And just think: You could even win a prize!

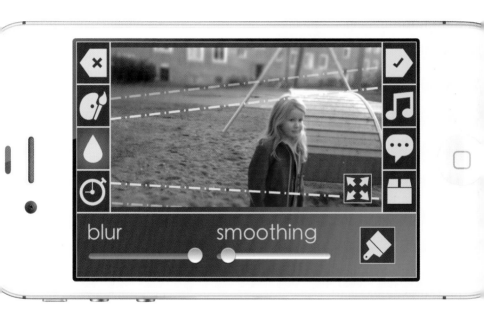

57 Tilt and shift your video clips

The illusion that you're looking at something tiny is created by an effect called "tilt/shift" (see tip 42). If you like that particular miniature effect, you should try the *TiltShift Video* app. It lets you add the effect to entire video clips, even to high-resolution ones. You can save your finished clips to the Camera Roll.

8mm Vintage Camera

58 Simulate a Super 8 movie

Super 8 was a popular format for recording film back in the seventies. Super 8 cameras are no longer made, but strangely enough there are still reels of film available to the enthusiast. You don't have to find your daddy's antique Super 8 camera in the attic, though. With your iPhone and the *8mm Vintage Camera* app, you'll have everything you need to give the old format a try. The app adds scratches and particles of dust, and you can choose between black and white and several other filters that give your clips just the right touch of old-time charm.

When you'd like to capture the entire atmosphere—for example, during your faraway vacation—this app is perfect. Record the sounds, the pulse, the hotel room, the screech of wheels on the railroad tracks, foreign languages, and the busy street. Show off your movie to friends and relatives in your forum of choice.

59 Live broadcasting

Would you like to be able to broadcast live video from an important meeting, a class, or perhaps a party? Well, you can do that with your iPhone. *Bambuser* is a free web service with an accompanying app that makes it possible to broadcast video clips in real time to selected friends—or the whole world. It also lets you chat with your viewers and share your clips via social media.

First you have to create an account with *Bambuser*. Then you log in via the app, press the record button, and you're on the air. After the broadcast, the app uploads your clip in high resolution to a web server where it can be made available to selected users.

Camera → PictureShow

Looking for tip 60?
Go back to the publisher's foreword and find it there!

Apps in Abundance

Almost all of the images in this book were shot with the built-in *Camera* app. They were edited in some of the many apps found in the *App Store* app on your iPhone. Here's an unsorted list of good apps. Some of them are free; others cost a few dollars. Don't be afraid to install and try those apps that catch your eye. You can create your own personal expression if you use several apps and combine different effects. Just go ahead—knock yourself out!

App Store
From the built-in *App Store* app you can find and download all the other apps.

Camera
Use the built-in *Camera* app to take pictures. Then edit them and apply effects with one or more of the other apps in this list.

Photos
The built-in image viewer and editor. Use it for basic editing, like color correction, rotation, cropping, or removing red-eye.

Hipstamatic
Imitates an old-fashioned camera. Change lenses, films, flashes, and filters.

Bambuser
Broadcast live web video to your mother or the whole world.

Lo-Mob
Exciting frames, effects, colors, and film imitations.

CameraBag
Simple and user-friendly app. Flick left

or right to see how your image changes with the 13 ready-to-use templates.

Infinicam
Choose filters, cameras, and photo frames. Touch Press for new camera to access new combinations to play with.

Dynamic Light
Get dramatic skies and mystical light in your images.

Bad-Camera
Take pictures that look like copies of old, ruined film with scratches.

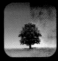

Old Photo Pro
Similar to
Bad-Camera.

Retro Camera Plus
Mimics old film with
dust, dirt, and
scratches.

Instagram
Take a picture and
share it immediately
with your friends on
Facebook and Twitter.
View and comment on
pictures from others.

PictureShow
Give your pictures a
retro feeling. Choose
between different
films, frames, and
effects (or defects)
like scratches, light
leaks, vignetting, and
noise. You can also
change colors and
contrast, and add
lighting effects.

Plastic Bullet
Imitates leaks, frames
your picture in exciting
light, and suggests
themes and colors.
It's like using expired
film or a leaky camera
that lets in light.

SwankoLab
A fun app with a
mystical darkroom
feeling. It gives a
nostalgic look back for
those who have made
prints in the darkroom.
Choose and mix your
own "chemicals."

Mill Colour
Choose between
templates that change
the colors, or adjust
the red, green, and
blue channels inde-
pendently for the
desired effect.

Picture Effect Magic
With the push of a
button you can

transform your image
into a piece of art.
Choose from oil paint-
ing, relief painting,
sepia, old film, solar-
ized photo, mirror
effects, neon light,
and more.

TiltShift Generator
A digital tilt/shift lens.
Make parts of the
image blurry.

OldCamera
A simple app that
produces random
black-and-white old-
fashioned looks.

Mustache
A silly party app. Paste
mustaches onto your
friends.

8mm Vintage Camera
Video app. Choose a
lens and type of film,
and add that charac-
teristic projector
rattling,

Photogene²
Gives you the opportunity to edit your pictures and change contrast, exposure, levels, saturation, and so on.

Makeover
Brightens and fixes your portraits, automatically or manually.

Camera+
Has more functions than the regular *Camera* app, like an unexpectedly good digital zoom, an image stabilizer, a self timer, and a continuous shooting mode. It also has many good functions for editing and photo sharing.

Flickr
Upload pictures to Flickr, one of the largest communities for photo buffs.

TouchUp Studio
An app with many options for exciting textures to add to your photos.

AutoStich
Stitch together awesome panoramas.

Fisheye4Free
Fake the fisheye effect with your iPhone.

Gorillacam
With this app you can zoom and take pictures with a self timer and a fast continuous shooting mode.

OldBooth
Paste your face in and see how you change with an old-fashioned haircut.

iSwap Faces
Upload two portraits of different people and swap their faces. A fun, but entirely meaningless game.

CamScanner
Archive paper documents, receipts, whiteboard notes, and so on. The app straightens the subject and makes text readable.

TtV Camera
View and capture the world through old, analog camera viewfinders.

Light Studio
An app that guides you in the art of creating simple and beautiful light. A fun way to learn studio lighting.

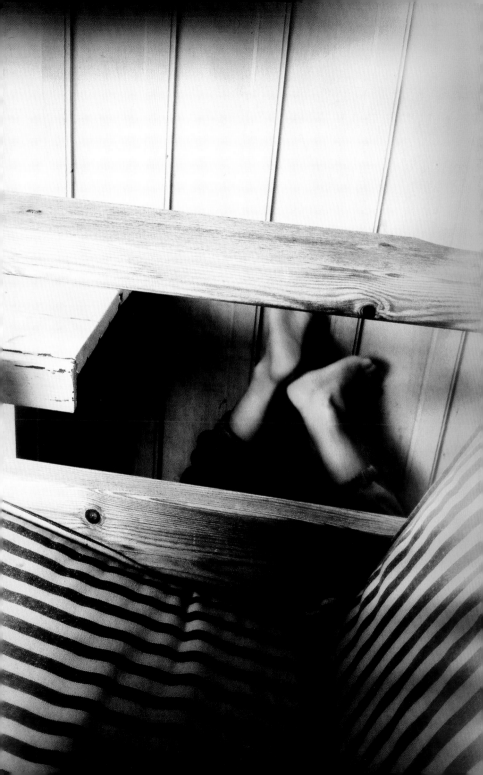

Index

Everyday

Take a portrait of yourself (or someone else) every day. The app shows the images in a movie sequence. A fun app, but it takes discipline to make the most of it.

Noir Photo

Noir Photo is an exciting app that you can use to change the light and mood in your images. It's a good app for anyone who wants to tell a story and create dramatic lighting.

iMovie

First record video clips in HD quality with the regular *Camera* app. Then open your clip in *iMovie*. Edit and add a soundtrack and effects. Combine several clips with smooth transitions. Upload the result to YouTube. Do it all without missing a beat.

Silent Film Director

With this app you can make movies reminiscent of old silent movies, with piano music, scratches, jerky style, and everything.

Photoshop Express

Nothing beats Photoshop for image editing on the computer. Now there's a lite version for your iPhone. With *Photoshop Express* you can do basic editing like reducing noise in your pictures.

TiltShift Video

The tilt/shift effect that makes everything look like a miniature is striking for video clips, too. You can decide where in your picture the simulated focus plane should be, and how blurry everything else should be.

Splice11

An alternative to the *iMovie* app, but with more functions for video editing: Change the speed of clips, change the volume, and rotate images.

Pixlr-o-matic

Another fun app with retro effects for your images. Mix types of film, lighting effects, and frames/edges almost infinitely. Save to your Camera Roll, upload to the web, or send your photos to a friend.

Dramatic Black & White

Convert to black and white, add noise, adjust contrast, add vignetting. It gives the right punch to your images.

... and much more is available for downloading in the *App Store*. Search, try, play, and shoot!

Afterword

The general interest in photography has never been greater. One indication is the explosive increase of images on the Internet. To those of us who happen to like photography, this development is inspiring. At the same time, it has become harder for us to get noticed, to stand out.

A couple of years back, *Fotografisk Tidskrift* published an eight-page article on photographers who had rediscovered the joy of taking pictures thanks to cell phone cameras, photo apps, and online publishing (Issue 5, 2010). The *Fotografiska* museum opened its doors to the public in 2010, and *Moderna Museet* began promoting the photographic arts shortly thereafter.

Your iPhone is made for letting you jump onto the digital image bandwagon so you can be a part of the inspiring development. With just a few taps on the display, you can share your images and video clips via Flickr, Twitter, Facebook, blogs, and web forums. On Flickr there are groups like "iPhone Camera Shots" and "Photos taken with an Apple iPhone." Tens of thousands of enthusiasts have together contributed close to a million pictures. Why not join?

But regardless of how much photo equipment you own and how much of the technology you master, your images will be no good unless you have something to say. It's your inner, personal voice that makes your images unique. Shoot with your heart, and try to take pictures that touch you. Then you will get noticed, and your pictures will also touch others.

Image Rights

All images by Martina Holmberg, with exception for the following pages:

Get in the Picture!

c't Digital Photography gives you exclusive access to the techniques of the pros.

Keep on top of the latest trends and get your own regular dose of inside knowledge from our specialist authors. Every issue includes tips and tricks from experienced pro photographers as well as independent hardware and software tests. There are also regular high-end image processing and image management workshops to help you create your own perfect portfolio.

Each issue includes a free DVD with full and c't special version software, practical photo tools, eBooks, and comprehensive video tutorials.

Don't miss out – place your order now!